IMAGES
of America

LONG ISLAND
RAIL ROAD STATIONS

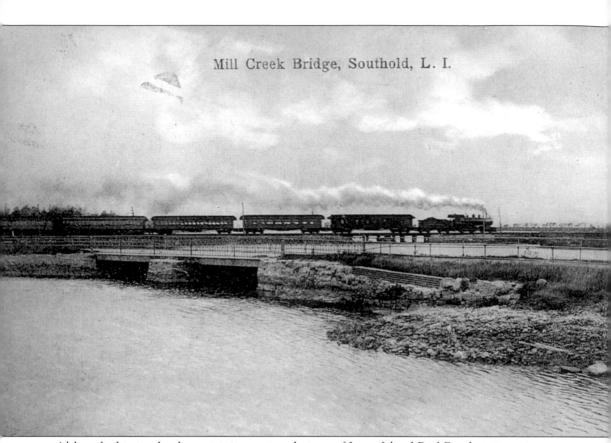

Mill Creek Bridge, Southold, L. I.

Although this is a book containing postcard views of Long Island Rail Road stations, it seems appropriate that the first image should be a train, for it was trains that connected stations, and they were the reason for the existence of the stations. In this postcard, postmarked May 20, 1912, a steam locomotive-powered passenger train chugs along the tracks at Southold, Long Island. This was a typical scene that was common throughout Long Island in the early part of the 1900s—the period depicted in most of the postcard views in this book.

IMAGES
of Rail

LONG ISLAND
RAIL ROAD STATIONS

David D. Morrison and Valerie Pakaluk

ARCADIA

Copyright © 2003 by David D. Morrison and Valerie Pakaluk
ISBN 0-7385-1180-3

First published 2003

Published by Arcadia Publishing,
Charleston SC, Chicago IL, Portsmouth NH, San Francisco CA

Printed in Great Britain

Library of Congress Catalog Card Number: 2003100290

For all general information, contact Arcadia Publishing:
Telephone 843-853-2070
Fax 843-853-0044
E-mail sales@arcadiapublishing.com
For customer service and orders:
Toll-free 1-888-313-2665

Visit us on the Internet at www.arcadiapublishing.com

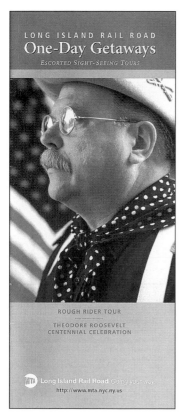

This book is dedicated to James W. Foote, a person with rare talent, who has been re-creating the persona of Theodore Roosevelt for more than 15 years, making history come alive. Foote has traveled the country as Roosevelt, performing at events such as the commissioning of the nuclear-powered aircraft carrier USS *Theodore Roosevelt* and appearing on national television. He is also a member of the Oyster Bay Station Restoration Committee. This image is a reproduction of the cover of a 1998 Long Island Rail Road tour brochure showing Foote as Theodore Roosevelt. (Reprinted with permission of the Long Island Rail Road.)

CONTENTS

INTRODUCTION

The railroad depot is the foremost symbol of the evolving period
of American civilization, of which there has been no replacement.

—Clay Lancaster

The Long Island Rail Road (LIRR), chartered on April 24, 1834, is the oldest railroad in the country still operating under its original name. For years, the Baltimore and Ohio Railroad was the oldest, but that changed with its 1987 merger with the Chesapeake and Ohio Railroad. The LIRR is also the nation's largest commuter railroad, running 740 trains and carrying 225,000 persons each weekday.

The purpose of this book is to present an image of how Long Island Rail Road stations appeared in the early 1900s, when picture postcards were at their height of popularity. The railroad had nearly 200 passenger stations, and hardly any two were alike. Some stations were designed and built by the railroad, and others were the result of community suggestions and funding. The varied designs and settings of the buildings have generated much interest over the years.

The images in this volume are supplemented by captions that reveal a bit of the history behind each station. Not all of the stations will be found in this book. Some stations were not pictured on postcards; other stations were pictured, but the postcards available were not of the best quality for publication. Some stations appear on two or more postcards, providing views from different angles. The authors' objective was to compile a postcard pictorial consisting of high-quality reproductions accompanied by interesting and informative captions.

The first five chapters contain postcard images of stations categorized by geographical area. The first chapter has postcards pertaining to Manhattan, the location of Pennsylvania Station. Penn Station is the major western terminal of the Long Island Rail Road and has been since the first LIRR train ran out of the facility on September 8, 1910. There are enough postcards of the station building, its vast interior spaces, and the tunnels to warrant an entire chapter. Chapter 2 covers Brooklyn and Queens stations, as well as the two other west-end terminals: Flatbush Avenue in Brooklyn and Long Island City in Queens. Chapter 3, "Nassau County Stations," looks at the Oyster Bay, Long Beach, Far Rockaway, Hempstead, and West Hempstead branches; major portions of the Port Washington, Port Jefferson, and Montauk branches; and some main-line stations. Chapter 4, "Suffolk County, North Shore Stations," includes the Port Jefferson and Greenport branches. Chapter 5, "Suffolk County, South Shore Stations," shows the Montauk branch from Amityville to Montauk.

The final chapter tells the story of railroad museums on Long Island. The smaller railroad museums, Wantagh and Lindenhurst, are covered first. The Railroad Museum of Long Island, which has sites in both Riverhead and Greenport, is also included. Finally, the upcoming railroad museum at Oyster Bay is explored. This is a truly exciting story because it involves the train station that was used by Pres. Theodore Roosevelt, who had a fondness for Long Island.

It is ironic that North Creek Station, in upstate New York, is on the National Register of Historic Places, while Oyster Bay Station is not. North Creek likely earned the honor because of a single moment involving Vice Pres. Theodore Roosevelt: in 1901, Roosevelt was at that station when he learned that Pres. William McKinley was dead. Yet Oyster Bay Station, which Roosevelt often used in traveling from his Sagamore Hill home, and summer White House, to Washington, D.C., has no marker indicating Roosevelt's frequent use. This will soon change, however, when the Friends of Locomotive No. 35 and the Oyster Bay Historical Society establish a railroad museum at the station.

Chapter 6 also includes postcards that illustrate the deep affection that Roosevelt had for railroads. He not only traveled by train but also liked to chat with the train crew at the end of a run, and he enjoyed climbing into a steam locomotive cab, probably fantasizing what it would be like to be the engineer. He was often seen on the rear end of an observation car during political campaigns, as well as when visiting such exotic places as the Isthmus of Panama. Long Island and the Oyster Bay Railroad Museum are indeed privileged to have the legacy of Theodore Roosevelt as a part of their railroad heritage.

Long Island is an area rich in railroad history, and it is hoped that this book will impart some of this history to its readers.

Bibliography

Diehl, Lorraine B. *The Late, Great Pennsylvania Station*. New York: American Heritage Press, 1985.

Seyfried, Vincent F. *The Long Island Rail Road – A Comprehensive History*, 7 vol. Garden City, New York: Exposition Press, 1961 to 1975.

Smith, Mildred H. *Early History of the Long Island Rail Road, 1834–1900*. Uniondale, New York: Salisbury Printers, 1958.

Ziel, Ron. *The Long Island Rail Road in Early Photographs*. Mineola, New York: Dover Publications, 1990.

Ziel, Ron, and George H. Foster. *Steel Rails to the Sunrise – The Long Island Rail Road*. New York: Meredith Press, 1965.

Ziel, Ron, and Richard Wettereau. *Victorian Railroad Stations of Long Island*. Bridgehampton, New York: Sunrise Special Limited, 1988.

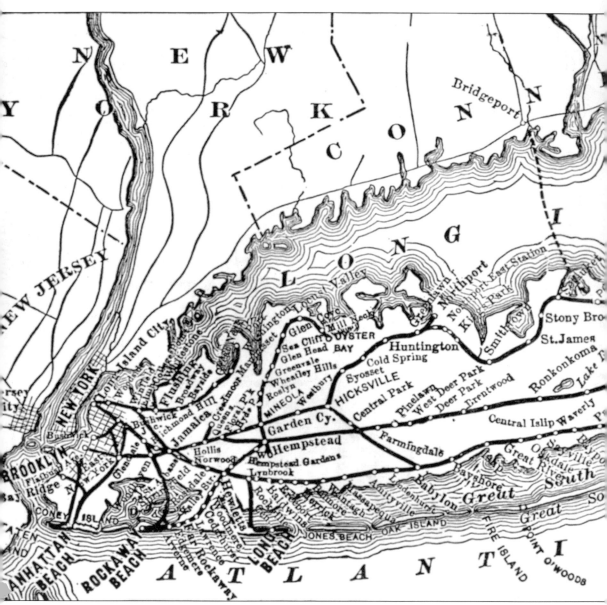

This map shows the Long Island Rail Road as it appeared in the early1900s. The railroad has nine branches, all of which, except the Port Washington branch, converge at Jamaica. Some trackage on the map is no longer in existence today: the line from Port Jefferson to Wading River, the Sag Harbor branch, the Whitestone branch, and the trackage west of Far Rockaway

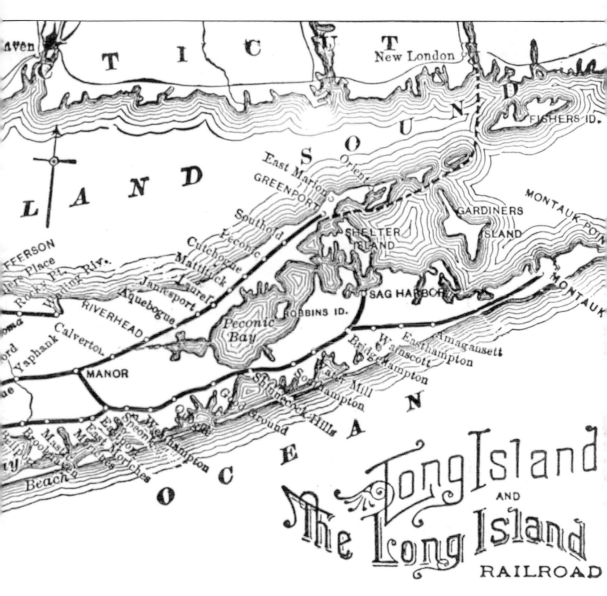

to Rockaway Beach. Anyone desiring a more in-depth understanding of the history of the LIRR should refer to the volumes listed in the bibliography on page 7. There are also several outstanding web sites where much LIRR history can be obtained.

ACKNOWLEDGMENTS

The authors owe a debt of gratitude to Hicksville historian Richard E. Evers, who was instrumental in convincing the authors to write this book. Evers, well known in Long Island history circles, is the author of *Images of America: Hicksville* and many other historical publications. Impressed with David Morrison's collection of Long Island Rail Road postcards, Evers suggested that Morrison work with Valerie Pakaluk to write this volume for Arcadia Publishing.

Unless otherwise noted, the postcards are from the collection of David Morrison, who got his inspiration to collect them from Carol Mills and Vincent F. Seyfried, both of whom have their own extensive collections of LIRR postcards. Mills and Seyfried and have very generously lent postcards to the railroad for historical displays, and a number of the postcards in this book are from their collections. Other contributors of images include Josh Soren of the Wantagh Preservation Society, Robert Myers of the Long Island Sunrise Trail chapter of the National Railway Historical Society, Gary Hammond of the Long Island Studies Institute of Hofstra University, and Michele Athanas of the Greenlawn-Centerport Historical Society.

It should be noted that much of the information in this book was derived from the writings of Vincent F. Seyfried and Ron Ziel, both of whom have written several outstanding Long Island Rail Road histories. The factual material in chapter 1, "Pennsylvania Station," relies heavily upon *The Late, Great Pennsylvania Station*, by Lorraine B. Diehl, whose passion for her subject shows throughout the book. Last but not least, thanks go to railroad historian Arthur Huneke for his invaluable information and advice.

Finally, a word of praise should go to the Long Island Postcard Club and several of its members who sell railroad postcards: Charlie and Nellie Huttunen, Joel Streich, and Randy Nelms. They not only sell postcards but also convey a great deal of wisdom on the subject, and are a pleasure to do business with.

One
PENNSYLVANIA STATION

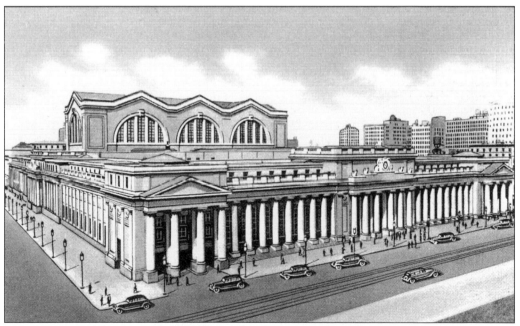

This is a view of the main façade of Pennsylvania Station from the corner of 7th Avenue and 31st Street. From its opening on September 8, 1910, Penn Station was the main western terminal of the Long Island Rail Road. Designed by McKim, Mead, and White, the building was supposed to last through the centuries. However, a scant 50 years later, it was demolished due to "the shortsighted acts of desperate men and the indifference of a sleeping city," as author Lorraine B. Diehl aptly stated. Today, Madison Square Garden stands where the great station once stood.

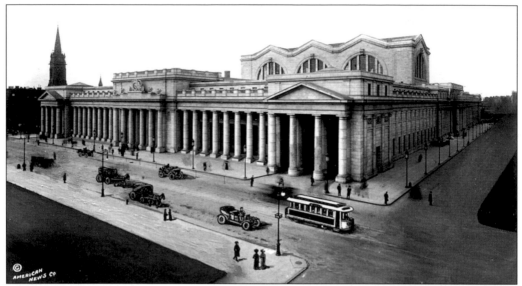

Here is another view of the main façade of Penn Station as seen from 33rd Street. The portions of the building on either side, with the pointed roofs, were carriageways. In the center of all four façades were statuary groups sculptured by Adolph Weinman. Two Roman figures surrounded a large clock, and on the sides of the figures were eagles. This great Doric-styled building cost $90 million to build and encompassed six city blocks, occupying eight acres of land.

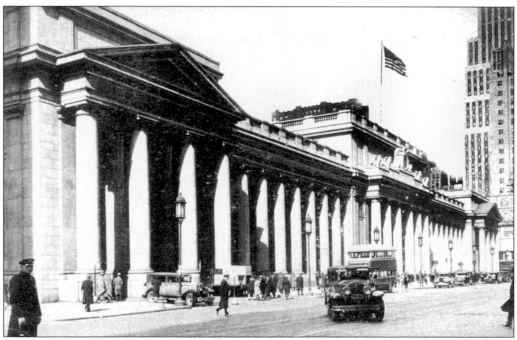

A vehicle exits the taxiway in this street-side view of the main façade. The pink granite used for the exterior was quarried in Milford, Massachusetts. The massiveness of the building, with its two-block row of 35-foot-high Roman Doric columns rising to the roofline, is evident here. Penn Station was truly a monumental gateway, built for the sole purpose of accommodating persons traveling by train.

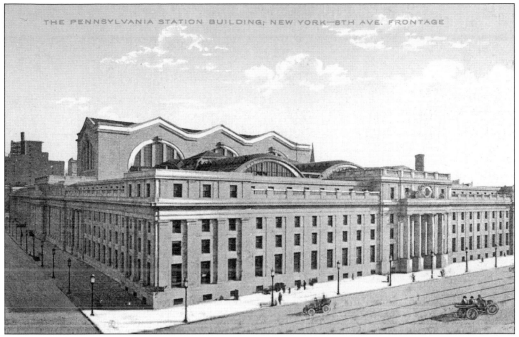

The less dramatic side of Penn Station was on 8th Avenue. Only four Doric columns and four eagles were found here, as opposed to the six eagles that were found on all other sides. This side of the building faced the General Post Office, which opened in 1913.

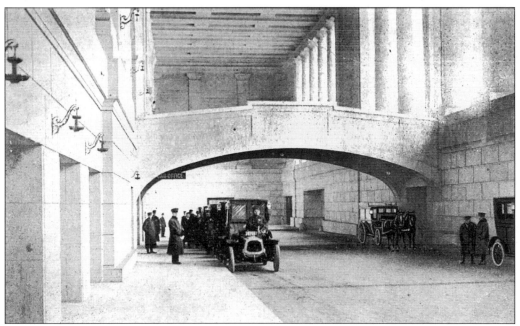

The north and south ends of the main façade had expansive carriageways, which gave visitors the sense that they were arriving at someplace very important. The carriageway entrances were based upon the design of the famous Brandenburg Gate in Berlin, Germany. In later years these passages become known as the taxiways.

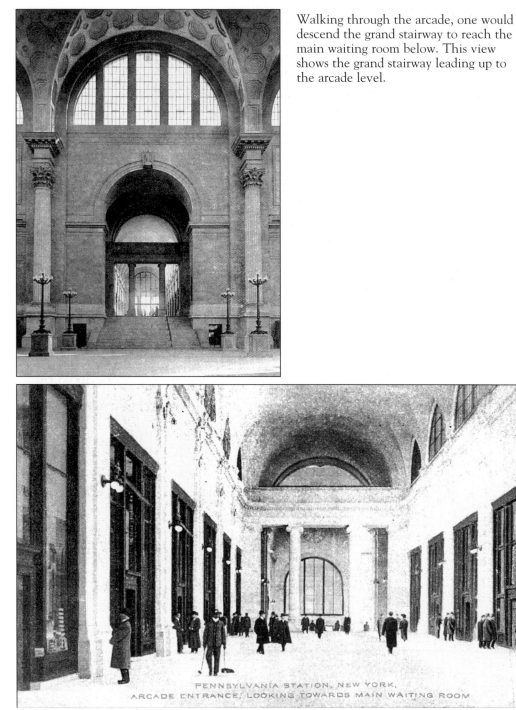

Walking through the arcade, one would descend the grand stairway to reach the main waiting room below. This view shows the grand stairway leading up to the arcade level.

PENNSYLVANIA STATION, NEW YORK,
ARCADE ENTRANCE, LOOKING TOWARDS MAIN WAITING ROOM

Anyone coming in the 7th Avenue entranceway on foot would walk through a long hallway known as the arcade. This high-ceilinged boulevard was lined on both sides with elegant shops. Near the arcade's vaulted ceiling were lunette windows that admitted beams of light, which shone down on the marble floors, much like the rays of light that shine through the windows at Grand Central Terminal today.

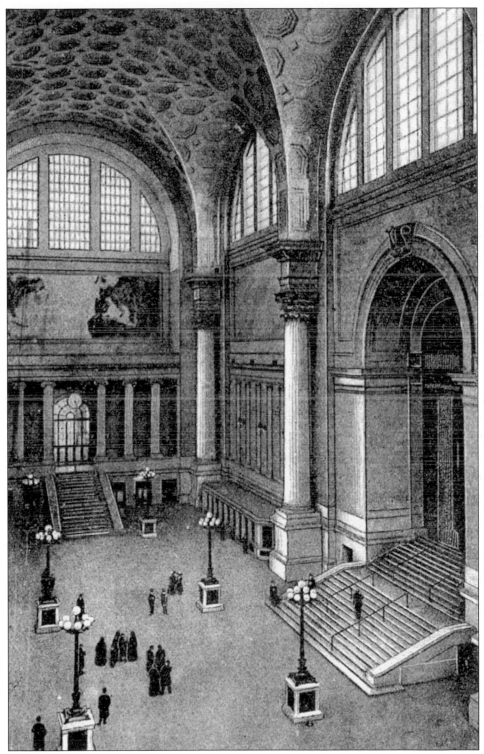

This is the main waiting room, with the grand stairway at the right. In the words of Lorraine B. Diehl, "this room was an immense cathedral clerestory."

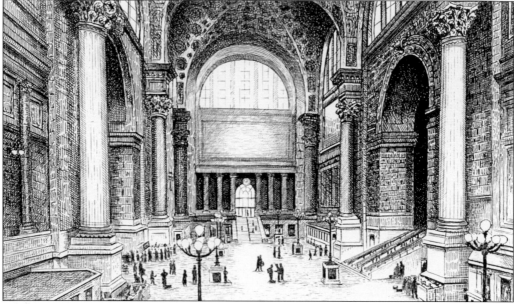

This postcard of the main waiting room is identified as being from a "genuine steel engraving." The room was designed in the style of the Roman Baths of Caracalla. The view looks toward the 33rd Street entrance. Upon descending the grand stairway at the right, one would cross the room and enter the passageway to the train concourse at the left. Not a single bench was found in the waiting room—seats would have distracted from the beauty of this vast open space.

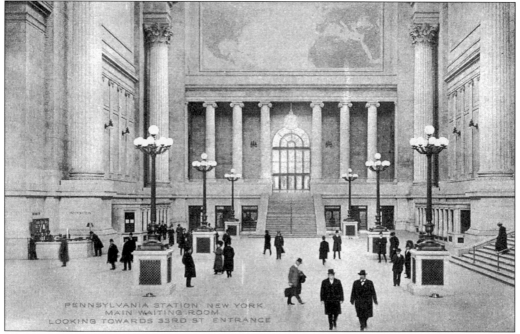

This illustration of the main waiting room depicts the beauty of the iron candelabra, which were mounted on marble pedestals and provided the main source of artificial lighting for the room. The information booth can be seen at the far left. A map of the world is seen above the 33rd Street entranceway.

The caption on the reverse side of this postcard reads: "Largest railroad waiting room in the world. Height is 150 feet, length 314 feet, and width 108 feet."

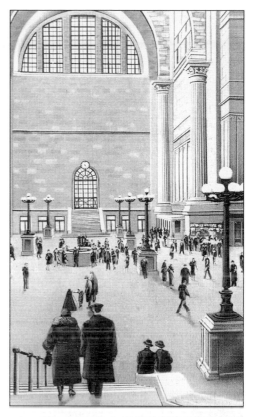

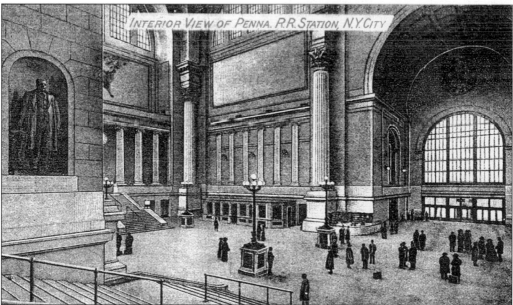

Pictured at the left is a statue of Alexander J. Cassatt, the Pennsylvania Railroad president who had the vision to build this great railroad station in New York City. Adolph Weinman, who sculptured all of the Penn Station statuary, cast the statue in bronze. The grand stairway led down to the main waiting room.

17

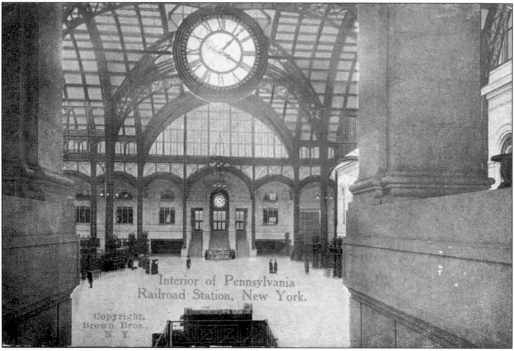

The main waiting room housed one of the many large clocks that were once located throughout the station. One of the old clocks from Penn Station can be seen today inside the LIRR's 34th Street entranceway. The railroad incorporated several remnants of the old station into the rehabilitation of its concourse in the mid-1990s. The steel framework seen outside the present LIRR waiting room is from the old Penn Station.

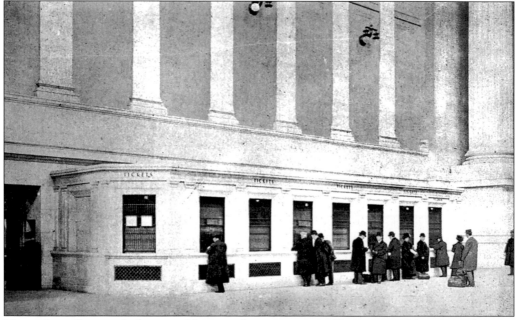

The ticket office, made from marble, gave the appearance of being carved from a single piece of stone. This postcard shows the area when it was bright and new.

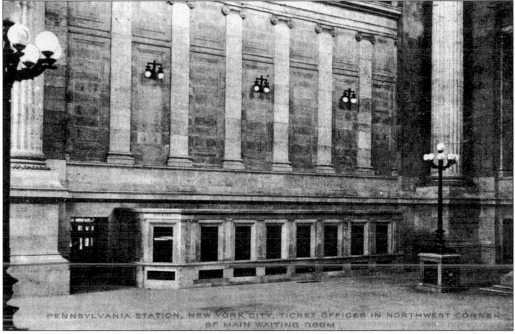

Time and neglect seem to have taken their toll, as seen in this postcard view showing the dirt and grime that has accumulated.

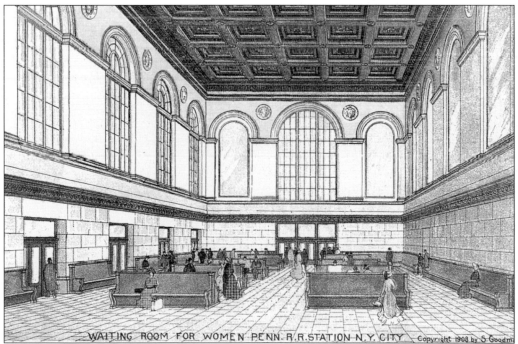

Fitting 19th-century customs, Charles McKim designed Penn Station with two separate waiting rooms, with benches, for men and women. Shown in this postcard is the waiting room for women. These auxiliary waiting rooms were not as intimidating as the enormous main waiting room.

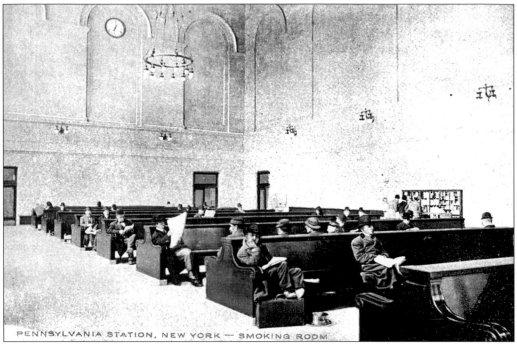

PENNSYLVANIA STATION, NEW YORK — SMOKING ROOM

Although this postcard is identified as the "smoking room," it is actually the men's waiting room. Of the doors in the background, the one at the right is for the smoking room and the others are for the lavatory and the barbershop. Lavatories were on the LIRR level, just below the men's and women's waiting rooms. An ornate cast-iron chandelier hangs from the ceiling.

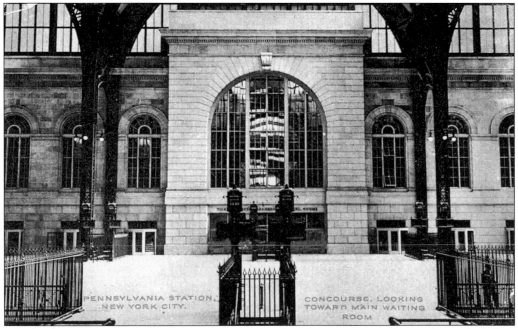

PENNSYLVANIA STATION, NEW YORK CITY. CONCOURSE, LOOKING TOWARD MAIN WAITING ROOM

This view shows the entrance doorway from the grand concourse to the mail waiting room. Over the doors is a large stone arch with a keystone at the top center. In the foreground are the stairways leading down to the track level.

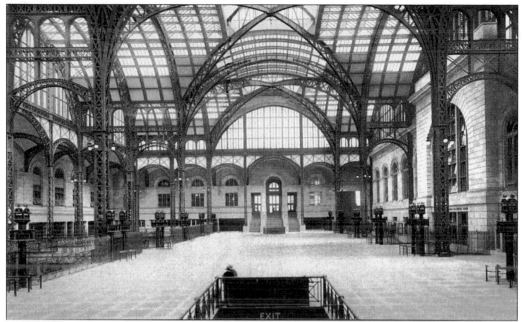

The ceiling of the concourse consisted of massive steel arches and glass. "If sightseers had been awed by the grandeur of the main waiting room, the concourse, with its enormous steel arches sweeping dramatically against the glass roof, gave one the unmistakable feeling that this was a place of journeys," author Lorraine B. Diehl wrote.

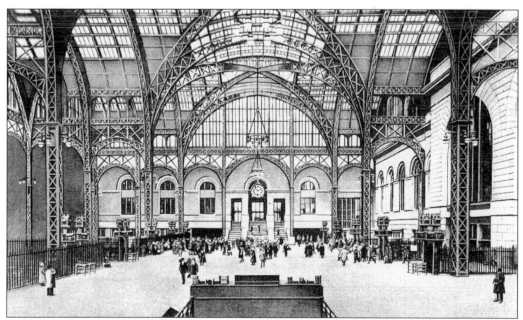

The floor of the concourse was made of small glass blocks that allowed light to shine down onto the track level. Until a few years ago, there was still a location inside the station where the glass blocks could be seen.

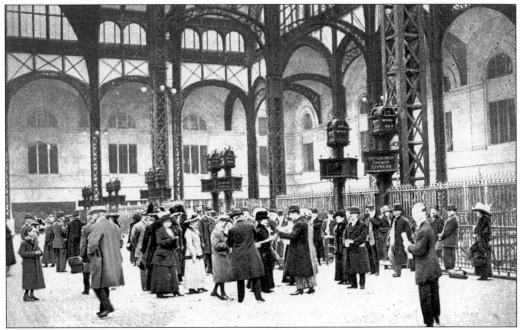

When on the concourse level, one could go to the gates and look down below at the trains coming into and pulling out of the station. Once again quoting author Lorraine B. Diehl, "In this train shed the mind journeyed long before the traveler set foot inside a train."

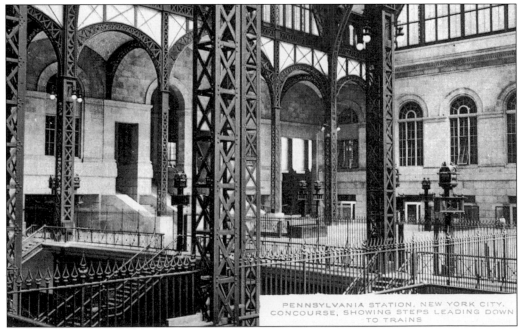

The stairways leading down to the trains were all open. The same stairways are present today but are enclosed with no feeling of the openness that once existed.

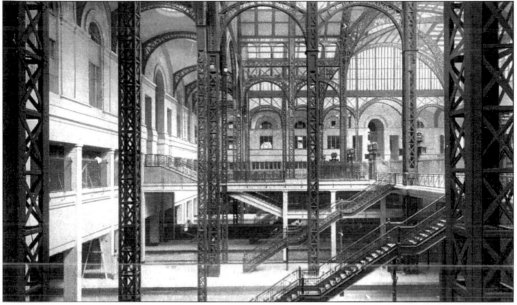

The same track, platforms, and stairways exist in the station today but with hardly any resemblance to this view. Although things look quite still, one can easily imagine the experience of the crowd motion and the train movement that took place here.

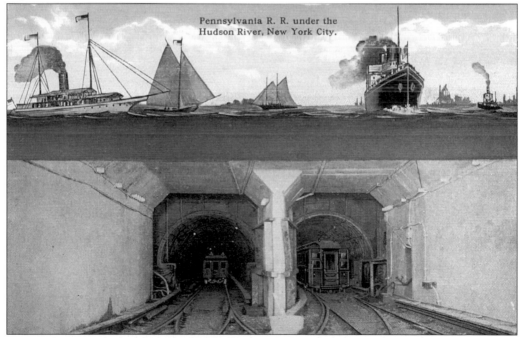

Pennsylvania R. R. under the Hudson River, New York City.

It was the tunnels underneath the Hudson and East Rivers that made it possible for the Pennsylvania Railroad to enter New York City. Pennsylvania Railroad president Alexander T. Cassatt had called upon the engineering talents of Samuel Rea to build the tunnels, electrify the tracks, and complete the great station complex. In 1930, a statue of Rea was placed opposite that of Cassatt's inside the station. Rea's statue can still be seen today. It is now outside, under the Madison Square Garden marquee.

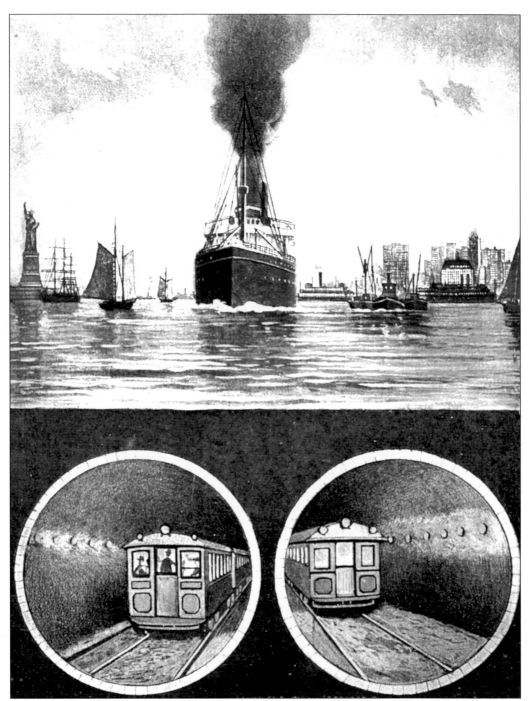

The East River tunnels carry LIRR trains and Boston-bound Amtrak trains. The tunnels also serve the Sunnyside Storage Yard, which is only a fraction of the size it used to be. Shown here is a cutaway of trains under the East River.

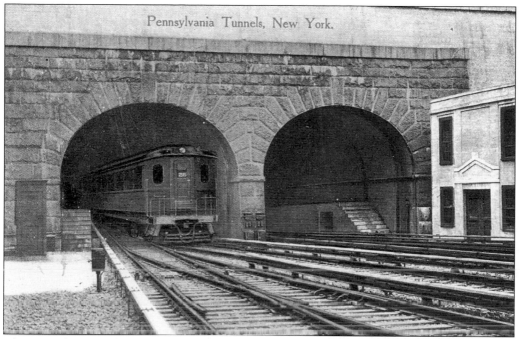

The tunnel portals were faced with granite quarried at Millstone Point, Connecticut. An electric commuter train is seen emerging from a portal in this scene. The steps leading up to the bench walls can be seen on the outer sides of these two tunnels.

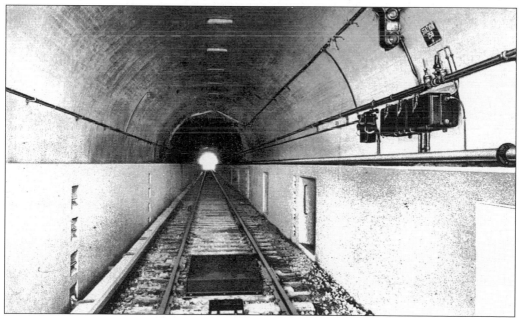

The bench walls on either side of the tunnels were designed to keep the train in the middle of the track in the event of a derailment. It also provided a walkway for maintenance and emergency workers. Inside the bench walls were cable runways. Note the signal appurtenances on the right side.

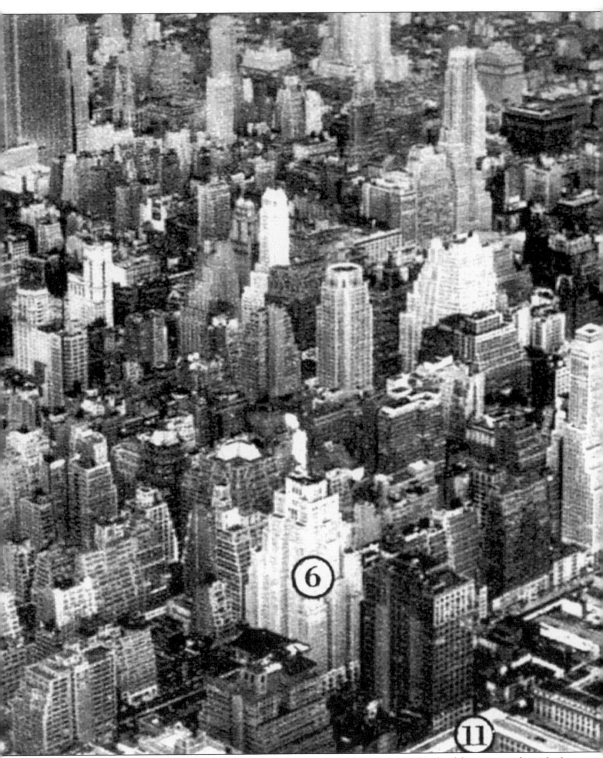

An aerial view shows Penn Station and surrounding buildings. The buildings are identified as (1) Empire State Building, (2) Penn Station, (3) Hotel Martinique, (4) Hotel McAlpin,

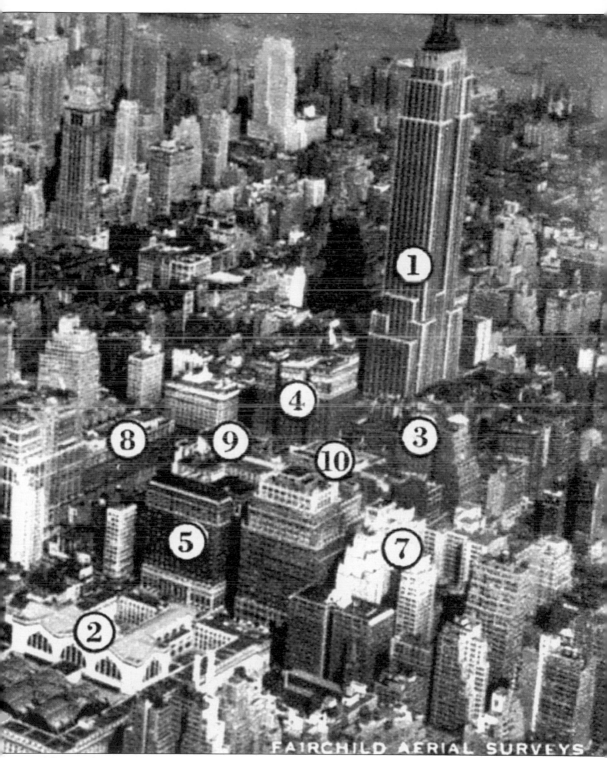

(5) Hotel Pennsylvania, (6) Hotel New Yorker, (7) Hotel Governor Clinton, (8) Macy's, (9) Saks 34th Street, (10) Gimbel's, and (11) General Post Office.

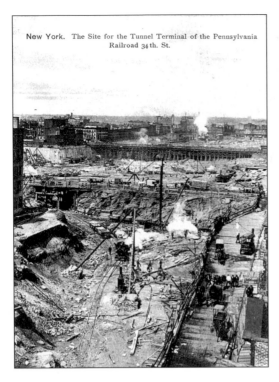

New York. The Site for the Tunnel Terminal of the Pennsylvania Railroad 34th. St.

On February 25, 1903, excavation for the building of Penn Station began and the first building was demolished to make way for the tunnel and station project. Throughout construction, 500 structures would be razed and 1,500 people displaced to make the project possible. Regarding the excavation work, author Lorraine B. Diehl stated, "one could really see the immensity of the Pennsylvania's invasion of New York."

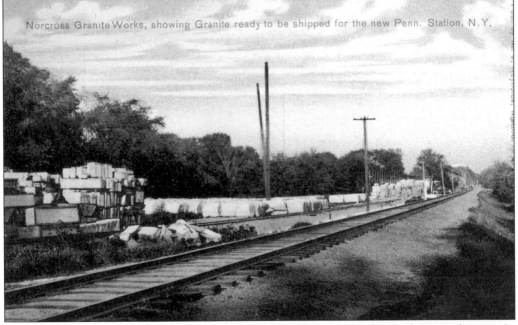

Norcross Granite Works, showing Granite ready to be shipped for the new Penn. Station, N.Y.

Stone for the exterior of Penn Station was pink granite quarried in Milford, Massachusetts. In this view, huge slabs of granite are seen trackside, waiting to be loaded onto railroad flatcars and transported to New York City.

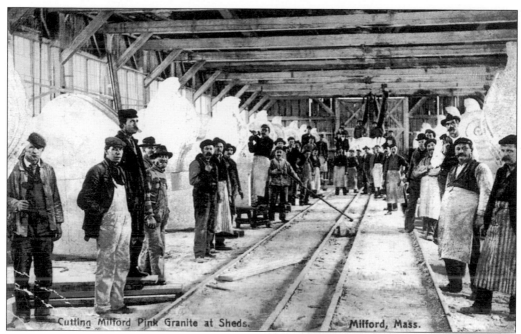

These carvings might not have been for Penn Station, but this image gives one an idea of the scope of work that went on in the Milford stone quarries. This view was taken inside one of the quarry's sheds. (Courtesy of Paul Curran.)

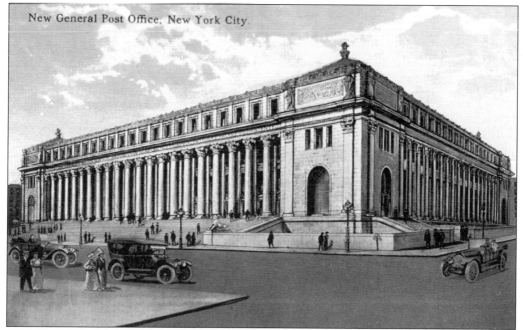

The General Post Office building, which opened in 1913, is located on 8th Avenue across the street from the old Penn Station. The federal government had the firm of McKim, Mead, and White design the structure similar to that of Penn Station, and it was built over the railroad tracks. Conveyer belts in the station allowed mail to be unloaded from railway post office cars and conveyed upstairs to the post office for sorting and distribution.

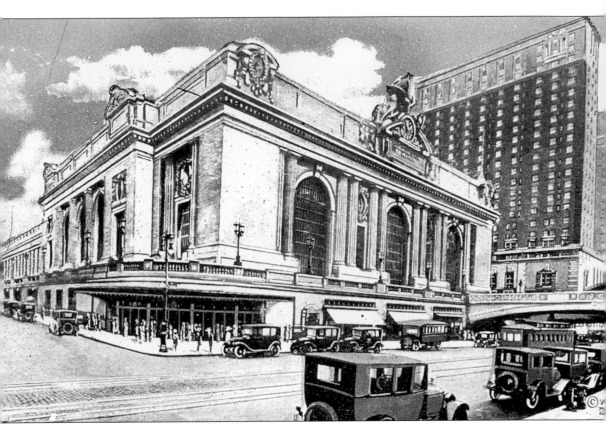

Why a postcard of Grand Central Terminal in a book about LIRR stations? The fact is that Grand Central survives today because of the historic preservation movement that arose from the dust of the demolished Penn Station. Jacqueline Kennedy Onassis led the fight to save Grand Central. In recent years there has been talk about bringing LIRR trains into Grand Central Terminal, using the 63rd Street tunnel. Whether those plans ever materialize, Grand Central's survival leads one to wonder what might have been had the great Penn Station also been spared.

Two

BROOKLYN AND QUEENS STATIONS

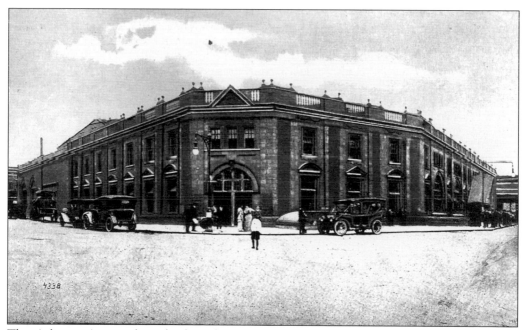

The Atlantic Avenue branch electrification began in 1905, and the new Flatbush Avenue Terminal opened to the public on April 1, 1907. Located at the corner of Hanson and Ashland Places and Flatbush Avenue, the terminal received extensive renovations in the 1940s. When the Dodgers left Ebbets Field for California in 1957, there was talk about demolishing the building and erecting a new baseball stadium on the site.

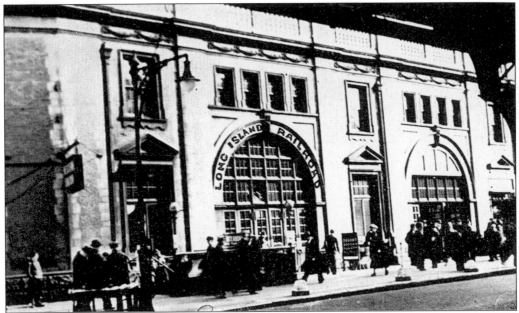

The Flatbush Avenue Terminal building was of American Italianate design, made from rough red brick and white limestone trim to create contrasting exterior coloration. There were large arches over the doorways, and two-story pilasters subdivided the long façade into bays. Bronze lettering on the arches spelled out Long Island Rail Road. In the early 1990s, the building was demolished and another chapter in LIRR history was closed. Nothing yet has been built in its place.

In this view of Hanson Place, the terminal is seen at the lower right. The Williamsburg Savings Bank is at the extreme left. The bank was built in 1927 and is still a well-known landmark in Brooklyn that can be seen from a considerable distance. In earlier years an underground passageway connected the bank building with the railroad terminal. The YMCA occupies the next large building in view, past the bank.

At Long Island City, LIRR trains connected with the 34th Street Ferry. The original Long Island City station burned down in December 1902, and a new station was opened on April 26, 1903. This building endured until 1938, when it was razed for the building of the Queens Midtown Tunnel. Even though there is no longer a building, the station is convenient to area business and New York City subway lines.

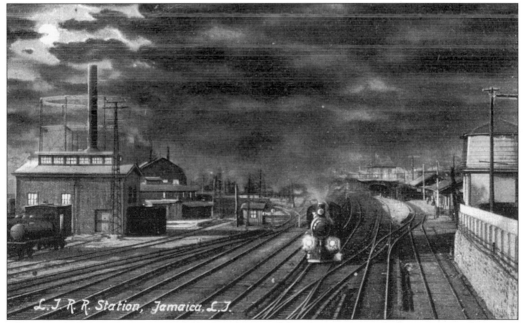

This view shows the Jamaica area prior to the construction of the present five-story station-office building. Nighttime LIRR views are rare: this one and the Hammel's Station view on page 44 are the only ones known to the authors. Rarer still are interior-views of LIRR stations. Other than the numerous ones showing the inside of Penn Station, no known postcards picture LIRR station interiors.

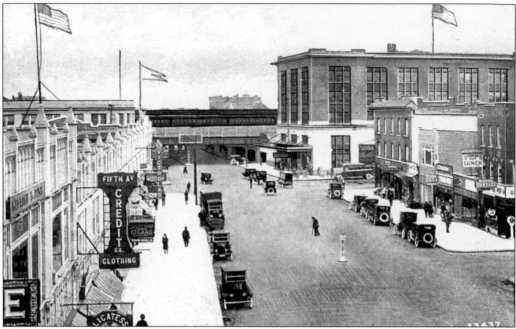

Developers predicted that once the LIRR had direct access into Manhattan, a gigantic building boom would occur on Long Island. To prepare for this, the railroad modernized, electrifying a number of branches and building a huge station and yard facility in Jamaica, the hub of the LIRR, where eight branches converge. The Jamaica Station building opened for public use on March 9, 1913, upon the arrival of the 4:47 a.m. newspaper train to Speonk. The five-story brick building was built on a foundation to support 12 stories, but the building was never expanded. In 2002 the Jamaica Station area was undergoing enormous changes with the construction of the JFK (Kennedy) Airport train terminal.

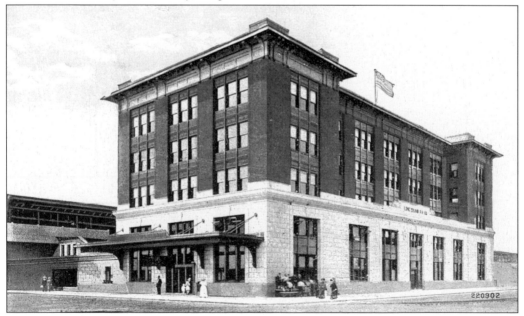

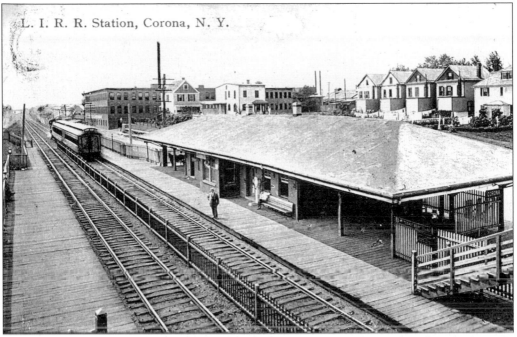

L. I. R. R. Station, Corona, N. Y.

Corona Station was close to the current Shea Stadium Station on the Port Washington branch. The station stop dates back to 1853. The building pictured in this view was the fourth station building on the site. The brick building was erected in 1894 and demolished in 1930.

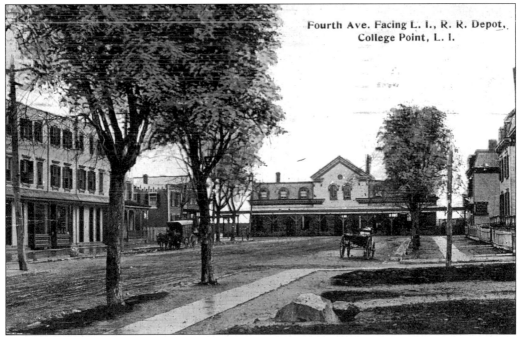

Fourth Ave. Facing L. I., R. R. Depot, College Point, L. I.

The College Point Station, on the old Whitestone branch, was in service from 1886 to 1932. The building was a two-story brick structure with a mansard roof. Opened on August 14, 1869, it remained in use until the end of rail service on the branch, on February 15, 1932. It was demolished on September 19, 1934.

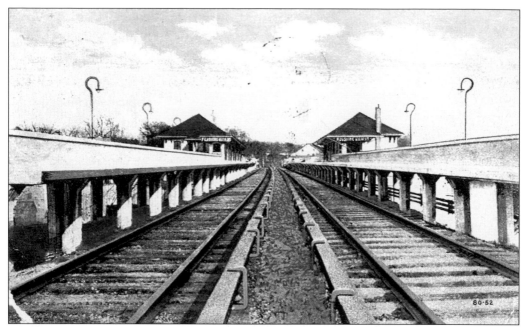

The Flushing Main Street stop got its first depot building in December 1853. The present elevated station opened for use on October 4, 1913. It was at this station that shoeshine shop owner Anthony Avena became legendary. Avena had been shining shoes at the station since 1922 and was 80 years of age in 1996, when the Metropolitan Transportation Authority (MTA) tried to increase his rent from $1,000 to $6,000 per month. Avena said that he could not afford the increase, and the MTA tried to evict him. However, New York Mayor Rudy Giuliani stepped in, and the MTA backed off. There are many LIRR stations with stories to tell.

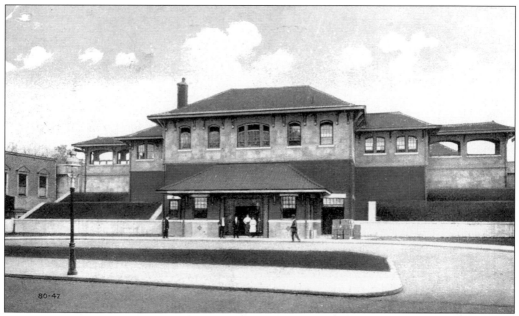

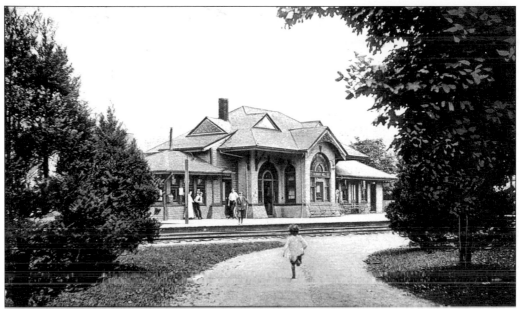

Murray Hill's first station, pictured here, opened in April 1889 and was torn down in October 1912. The railroad tracks were depressed below grade level through the area in 1913. A new station opened in July 1914 and was torn down in September 1964. (Courtesy of Vincent F. Seyfried.)

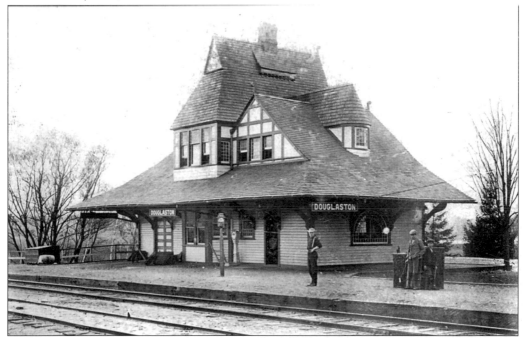

Douglaston's first station was built in 1867. A new Queen Anne–style station, shown here, was erected in 1887, demolished in 1962, and replaced by the mundane brick-and-glass structure that stands today. Fortunately, the Douglaston Historical Society maintains a fine display of historical photographs inside the waiting room so that railroad customers can see how beautiful the station was in years past. (Courtesy of Vincent F. Seyfried.)

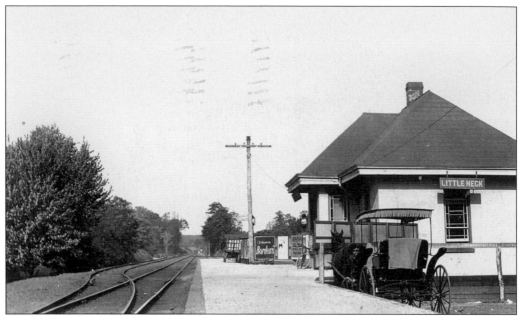

In 1890, this brick station in Little Neck replaced the original station, which had opened in May 1870. Little Neck is one of the few stations within the New York City limits that still have a grade crossing. This postcard includes an excellent view of a horse and buggy at the station. (Courtesy of Vincent F. Seyfried.)

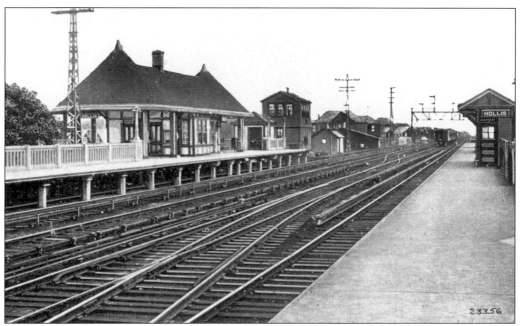

Hollis, originally known as East Jamaica, got its first station building in 1885. The structure was a unique wood-frame building with a cupola on each end. Unfortunately, vandals burned down the building on November 2, 1967. Today, the station consists only of high-level platforms and a shelter shed.

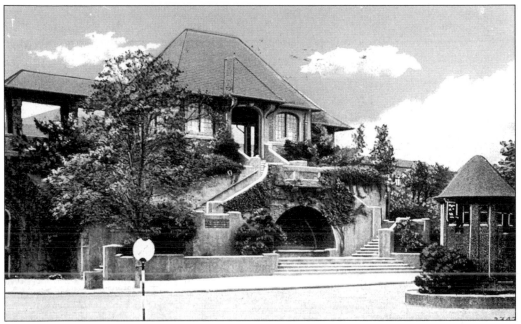

New mainline service out of Penn Station in 1910 was responsible for the creation of the "suburban city" of Forest Hills Gardens and the new train station at Forest Hills. Opened on August 5, 1911, the station was built in English Tudor stucco, set off with red brick and a red tile roof, in keeping with the grand architectural scheme of the Gardens. On the station's south side, seen in these views, there is a grand staircase where Theodore Roosevelt delivered his Unification Speech on July 1, 1917. (Below, courtesy of Vincent F. Seyfried.)

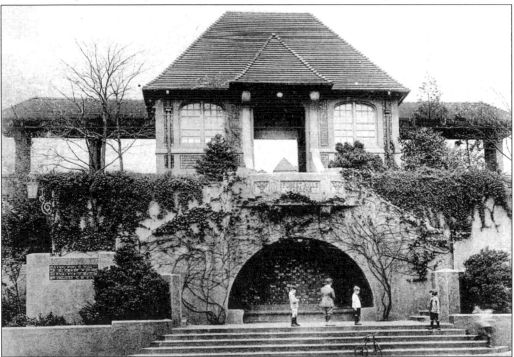

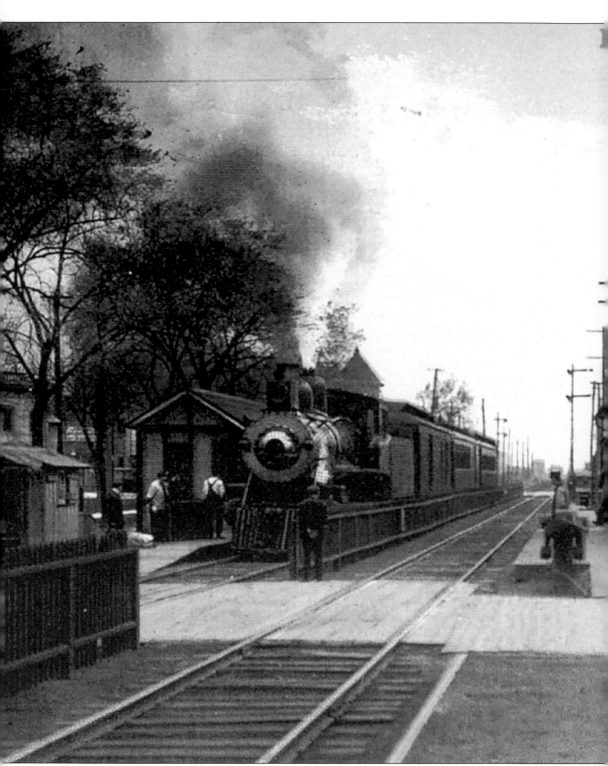

The Richmond Hill depot building was erected in 1869 on Myrtle Avenue at its junction with Jamaica Avenue. The name of the station was changed from Clarenceville to Richmond Hill

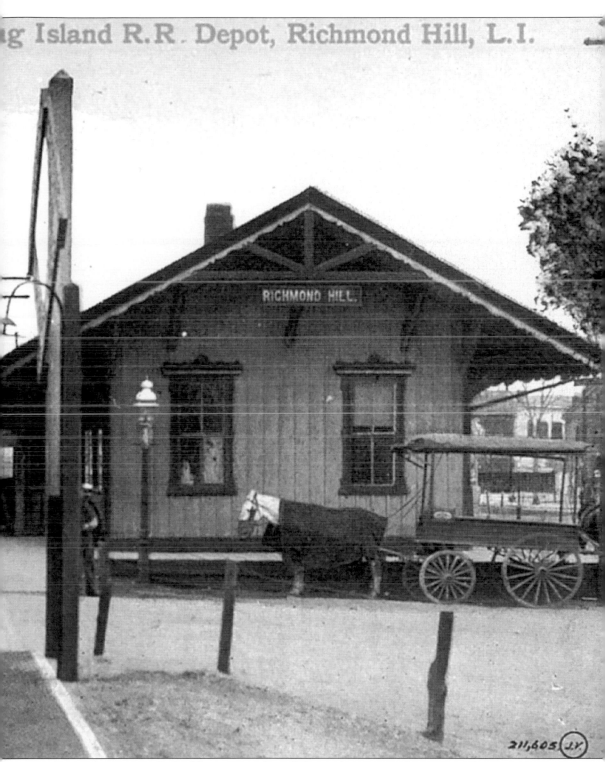

211,605 J.Y.

in November 1871. The building survived until the grade crossing elimination of 1923. Notice the gas lantern to the left of the blanketed horse.

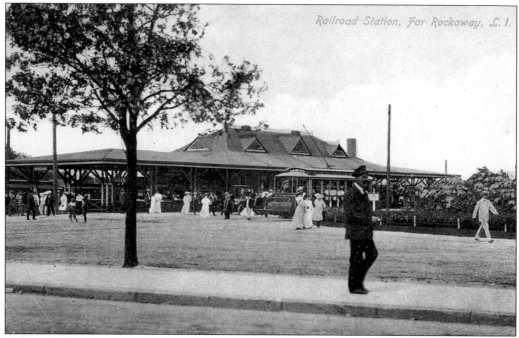

At Far Rockaway Station, a new brick building opened on July 15, 1890. In 1897, the Ocean Electric Trolley was incorporated by the LIRR as a feeder service for the Rockaway Peninsula. The second floor of this station building housed the headquarters of the trolley line. The trolley made a dead-end loop at this station. The trolleys ran until September 9, 1926. On October 2, 1955, all LIRR trains terminated at Far Rockaway and service west was taken over by New York Transit. This building was razed in 1957.

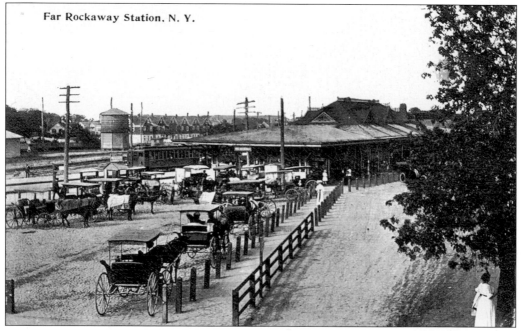

Far Rockaway Station, N. Y.

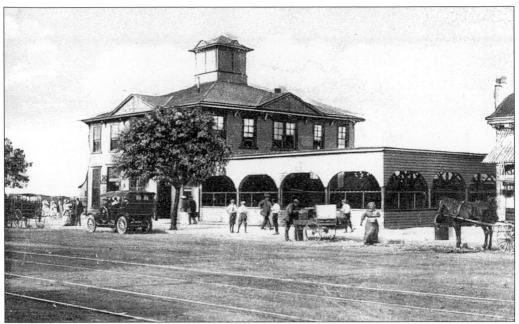

A two story depot building opened at Rockaway Beach in May 1882. The name was changed to Rockaway Park in 1889 when the village laid out plans for development. In the spring of 1889, the depot area was enlarged with extra tracks and an elevated loop to turn the Brooklyn Rapid Transit trains.

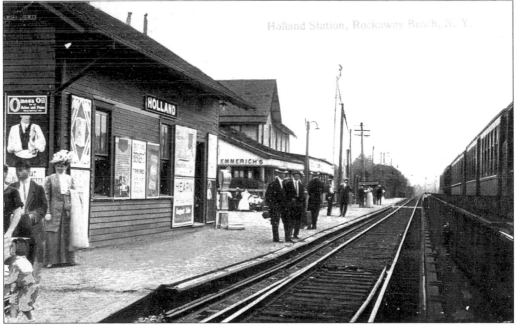

Holland Station was named after the adjacent hotel of Michael P. Holland, which was located at what is today the northwest corner of Holland Avenue and Beach 92nd Street. The station building was erected in 1880, overhauled in 1899, and enlarged with a new baggage room in 1914. Service was discontinued at this station in 1941.

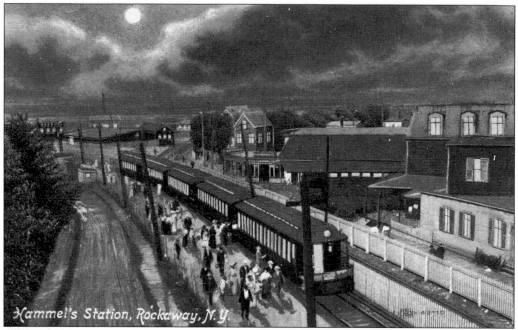

Hammel's Station, Rockaway, N.Y.

At Hammel's Station the LIRR tracks from Jamaica reached land and the route divided: Rockaway Beach branch trains went west, and Far Rockaway trains went east. Hammel's Station opened in 1886 to serve the two hotels that were on the shore of Jamaica Bay. This station was abandoned in 1941. The above view and the postcard at the bottom of page 33 are the only known night-view LIRR postcards. The postcard below shows an Ocean Electric trolley at the station.

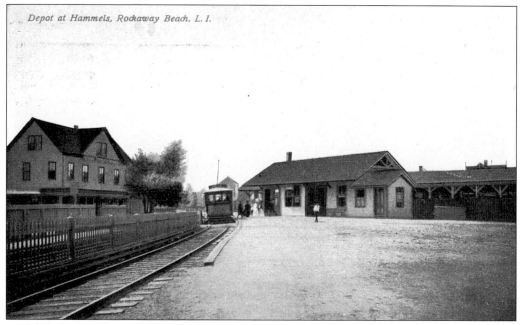

Depot at Hammels, Rockaway Beach, L.I.

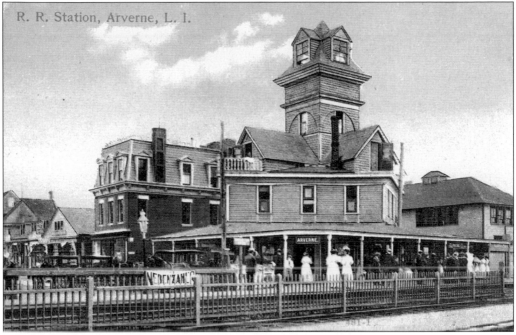

R. R. Station, Arverne, L. I.

In 1888, Averne Station was established and a depot with a large tower was built. This building lasted until 1912, when it was replaced with a simpler building.

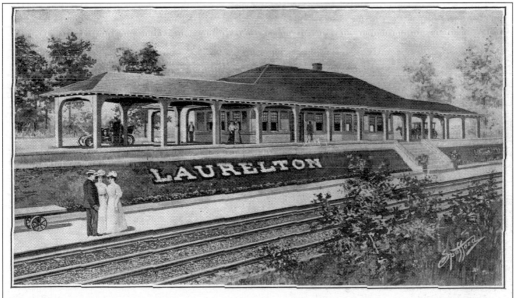

The $15,000 Station now being built at Laurelton by the Long Island R. R.

(Tear off here and keep upper half. Sign, stamp and mail lower half)

Laurelton Station opened in April 1907. The Laurelton Land Company, in connection with a housing development of French- and Spanish-type stucco houses with tile roofs, erected this building. The depot was torn down in 1950 in connection with the grade crossing elimination project. A real estate company issued this postcard to promote land sales in the area. (Courtesy of Carol Mills.)

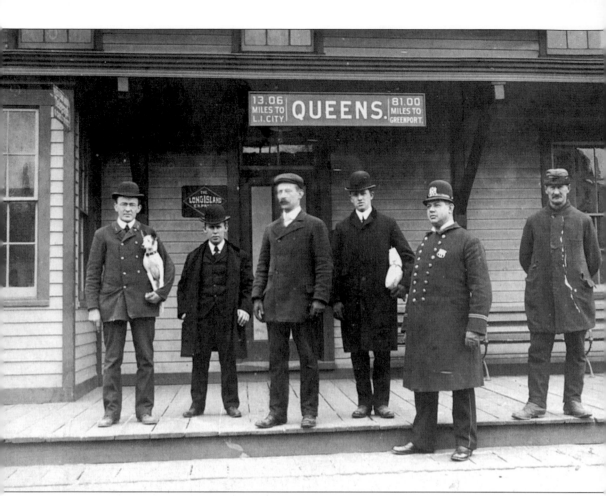

A clapboard-sided building was erected at Queens Station in 1871. The station name sign indicated that the station was 13.06 miles from Long Island City and 81.00 miles from Greenport. The man to the left, holding the dog, could very well be a railroad conductor, judging from his attire and the patches that are on his collar. It is unknown whether the officer in the foreground is a railroad policeman or a local one. Queens became Queens Village c. 1920. The wood building was demolished in 1924 and replaced with the current, high-level structure that opened on September 20, 1924. (Courtesy of Vincent F. Seyfried.)

Three
NASSAU COUNTY
STATIONS

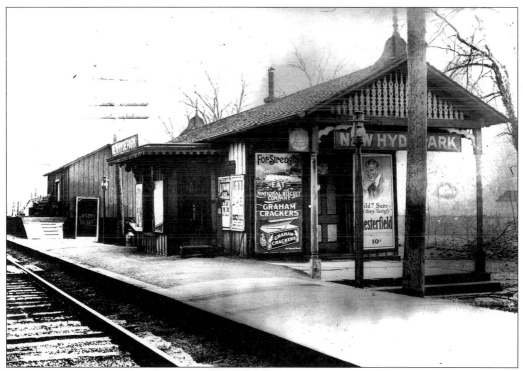

New Hyde Park was once known as Hyde Park. In 1898, the name was changed to conform with a postal regulation specifying that no two towns in the same state bear the same name. Hyde Park already existed midway up the east side of the Hudson River. The New Hyde Park Station building, pictured here, dates back to 1870. It survived until 1947, when it was replaced by the current building. (Courtesy of Arthur Huneke.)

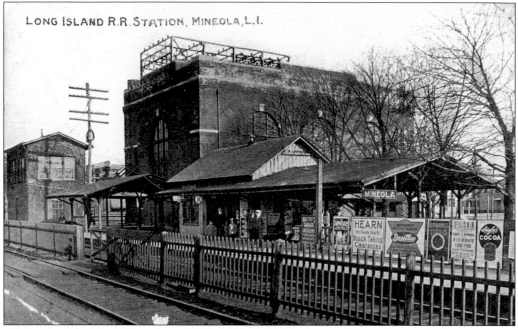

This view shows the original Mineola Station building, erected in 1883. It was located on the south side of the tracks at the east end of the station. The large brick structure behind the station building is the electrical substation built in 1922. The east canopy of the station building had to be moved closer to the tracks to make room for the substation building. At the left is the old wooden signal tower, known as MT Tower, where Nassau Tower currently stands. The wood tower was destroyed in a train wreck on December 20, 1922.

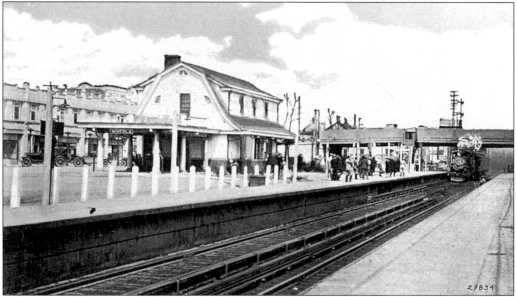

On September 22, 1923, the new Mineola Station opened on the north side of the tracks about mid-platform. It was set back from the tracks in anticipation of the installation of a third track through the area. The building once housed the station agent and family. Today, it serves as headquarters for the LIRR's branch line managers.

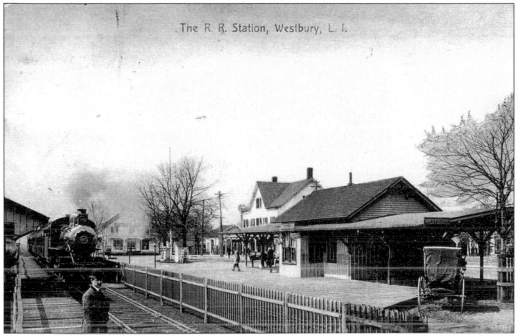

In 1914, a stucco building replaced the original Westbury Station building, pictured here. The fence between the tracks—at one time common at many stations—was there to discourage people from crossing over the tracks to get to the platform on the other side. For years Hicks Nurseries has donated the landscaping services for the station grounds.

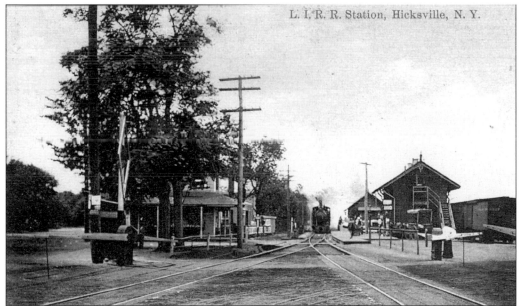

Hicksville was named after Valentine Hicks, the second president of the LIRR. Between 1837 and 1841, Hicksville was the eastern terminus of the railroad. The railroad expanded east to Farmingdale in late 1841 and, again, to Syosset in 1854. Here, the tracks are shown dividing, with the Port Jefferson branch going off to the right and the main line to Greenport going off to the left.

49

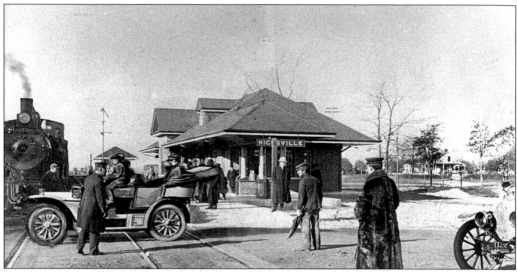

Shown is the 1909 brick station in Hicksville. The view is looking west from Jerusalem Avenue. The flagman was there to control the increasing automobile traffic. There are no known photographs of the north side of the station building. (Courtesy of the Long Island Studies Institute.)

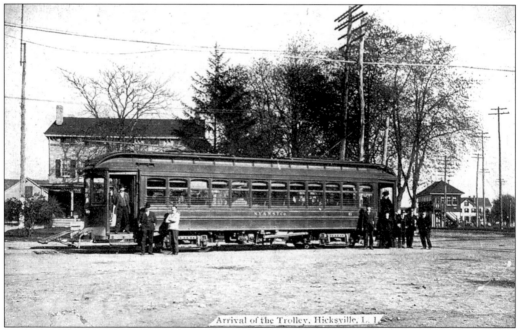

Arrival of the Trolley, Hicksville, L. I.

At one time a trolley line ran from Hicksville to Mineola. One of the trolleys is shown on this postcard with the lettering "NY & NST Co.," referring to the New York and North Shore Transit Company. In the left background is the 1835 Grand Central Hotel, and in the right background is the old wood signal tower known as Divide.

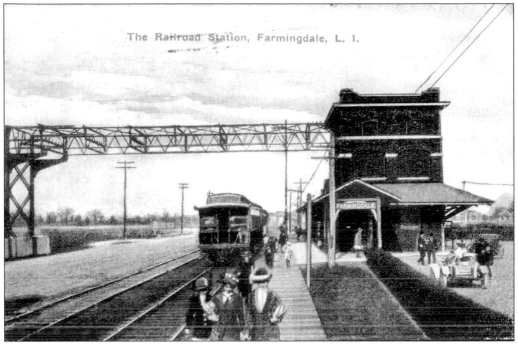

The Railroad Station, Farmingdale, L. I.

Erected in 1895, the Farmingdale Station building is a brick structure, similar to the station building in East Hampton. In 1910, when the trolley from Huntington was extended to Amityville, with a stop at Farmingdale Station, the two-story electrical substation was built on the west end of the station building. The bridge structure going across the tracks was the support system for the trolley electrical cables. Not far from Farmingdale Station, the famous bicycle ride of Mile-a-Minute Murphy took place on June 30, 1899.

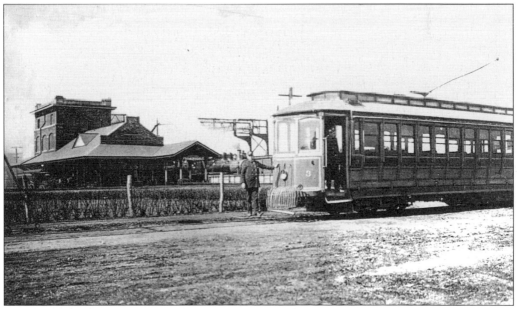

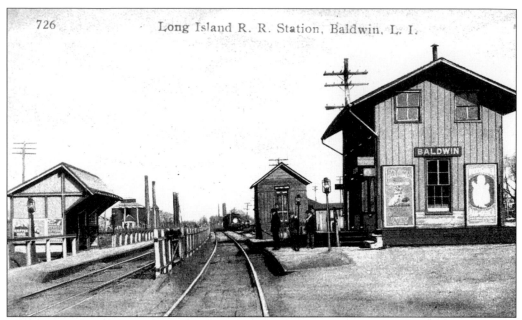

Long Island R. R. Station, Baldwin, L. I.

A two-story wood building was erected at Baldwin in 1868. This postcard offers a good view of the platform shelter shed across from the station building. Most stations have such structures to protect passengers on the off-building side. This old building was replaced in 1917.

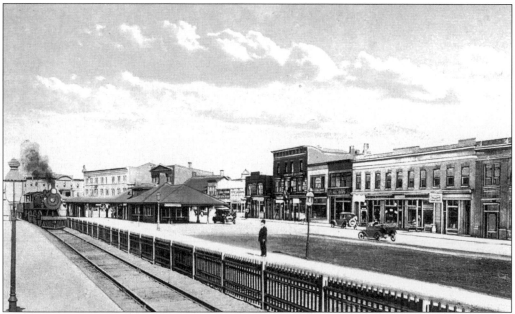

The Freeport Station building opened in 1899. The building was almost identical to the one in Garden City. When the railroad was electrified through the area in 1925, Freeport Station drew many more passengers. This building was razed in 1959 as part of the grade crossing elimination project.

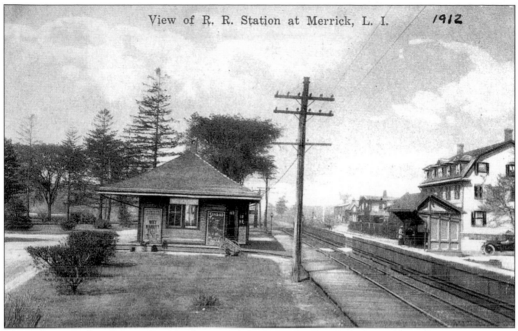

View of R. R. Station at Merrick, L. I. *1912*

Merrick got its first station building in 1885, built by the South Side Rail Road. Then, in 1902, the structure shown above was erected. It was razed in June 1969 due to the grade crossing elimination project. Merrick Station still has the monument that was placed in 1914 for Roxie, the LIRR dog (see page 123). (Courtesy of Vincent F. Seyfried.)

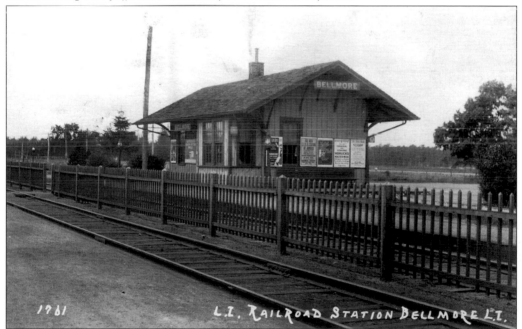

L.I. Railroad Station Bellmore L.I.

The Bellmore Station building was erected in 1869 and razed in 1969. A poster on the building advertises "The new station at Jamaica," making this view *c.* 1913. One of the old wooden platform shelter sheds at the station has been preserved by the local Boys Scouts. (Courtesy of Carol Mills.)

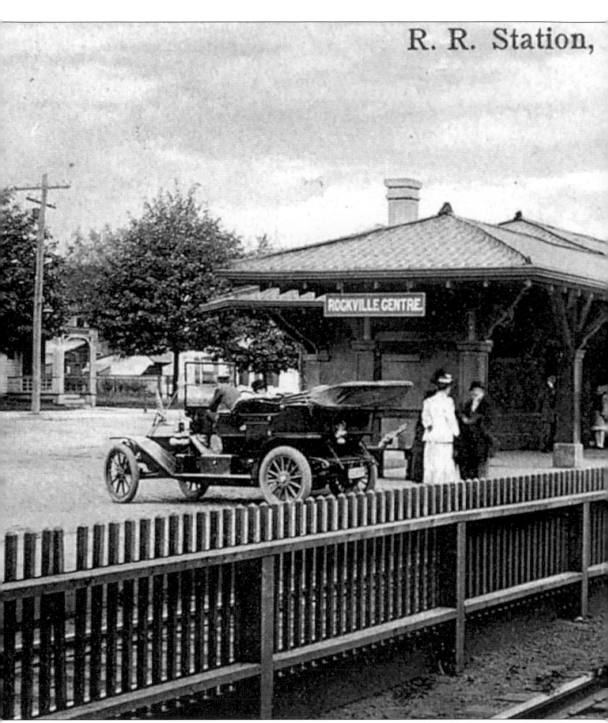

The first Rockville Centre Station building was a wood structure that still exists. It is located behind a vacant building that once housed a restaurant on Wood Avenue. There are no known photographs or postcards showing this building when it was trackside. The building shown above, the second Rockville Centre Station building, opened on October 4, 1901. It was razed in March 1949 due to the grade crossing elimination. Rockville Centre was the scene of one of

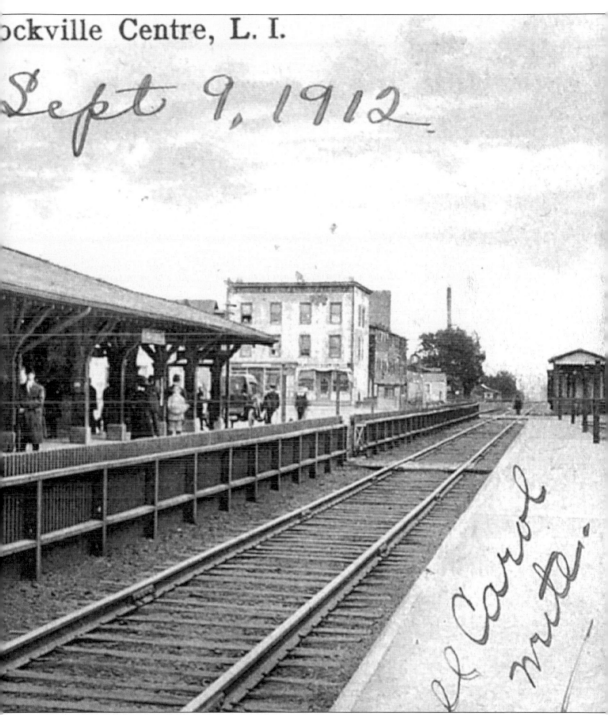

ockville Centre, L. I.

Sept 9, 1912

Carol Nutli

the worst LIRR train accidents. On February 19, 1950, two passenger trains collided on a gauntlet track that was constructed in conjunction with the grade crossing elimination work. Thirty-five persons died. Later that year, another tragic accident, in Richmond Hill, led to the installation of automatic speed control on the LIRR.

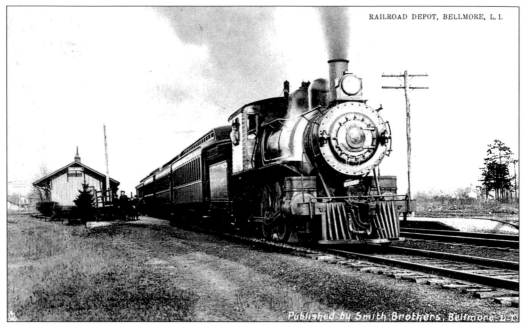

Steam Locomotive No. 84 is the focal point of this view of the Bellmore Station. This postcard, postmarked 1909, gives a good idea of how desolate the area was at the time. (Courtesy of Vincent F. Seyfried.)

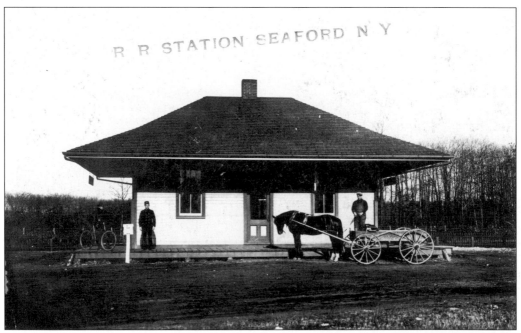

Seaford Station, a basic clapboard-style box structure, opened in 1899. Although there is little if any decoration on this structure, the horse-drawn wagon dresses up this view. (Courtesy of Carol Mills.)

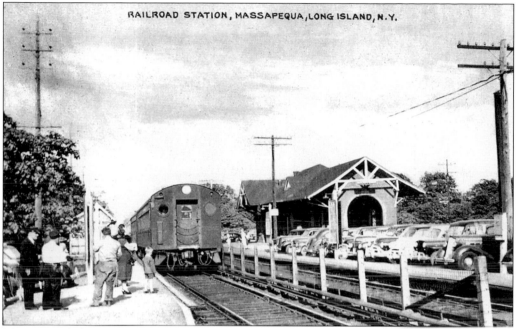

Massapequa's first station opened when the area was known as South Oyster Bay. In 1889, the community was renamed after a local American Indian tribe. The building seen here opened in 1892, and this view probably dates from the late 1940s.

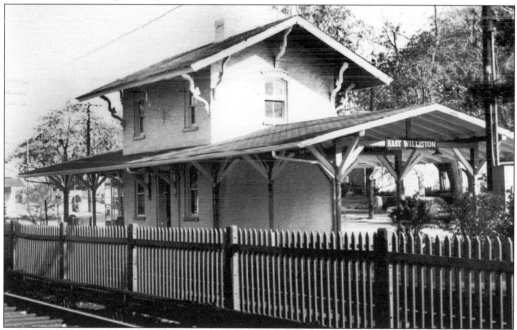

East Williston Station is still housed in its original building, which opened in 1880. It is the third-oldest station building on the LIRR, after only Hewlett and St. James Stations. This brick building was probably the first station that the LIRR built in masonry. In the 1920s, there were plans to electrify the branch and a third rail was laid to the station, but the electrification plan was never completed.

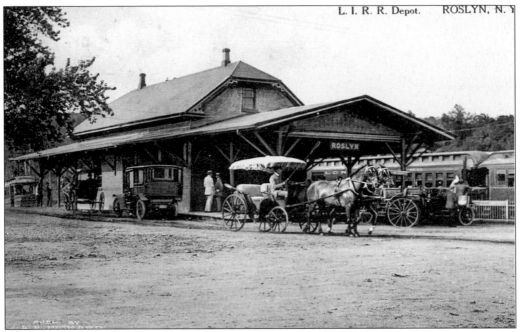

Rail service began at Roslyn on January 23, 1865, with a wood-frame building. The present structure, seen here, was built in 1887. It was brick at ground level and stucco on the second level. The building was moved some 30 years ago to a location farther west, where it remains today. Thanks to the efforts of the Friends of Locomotive No. 35 and the Roslyn Landmark Society, there is a potbelly stove, for decorative purposes only, in the waiting room to bring back a little flavor of the good old days. (Courtesy of Vincent F. Seyfried.)

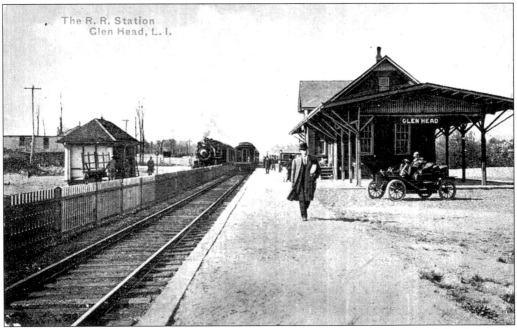

Glen Head and Sea Cliff Stations both acquired new buildings in May 1888. The structures were brick, with canopies on each side. The Glen Head building was demolished in 1961.

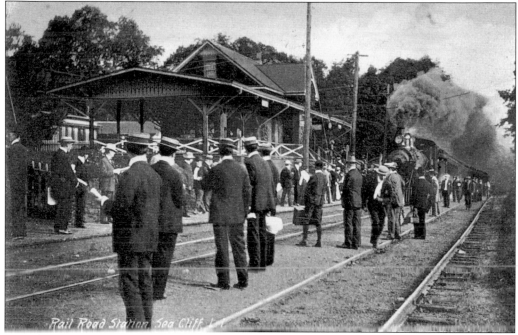

The 1888 brick station building at Sea Cliff still stands. The design of the canopies on each side of the station building made the structure unique. There are intricately designed jigsaw-pattern screens beneath the canopy ends, with balustrade-like sections leading back to the building. Ornamental brackets support the canopy and building eaves. This station is the sole surviving example of the elaborate canopy bracing that once graced at least six LIRR stations, the others being Amityville, Patchogue, Roslyn, Glen Head, and Queens Village. Between July 2, 1902, and December 21, 1924, the LIRR operated a trolley line into Sea Cliff Village. Trolley cars stopped in front of the building, on the side abutting the parking lot. The building and canopies underwent a historical restoration in 1997. (Above, courtesy of Vincent F. Seyfried; below, courtesy of the Long Island Studies Institute.)

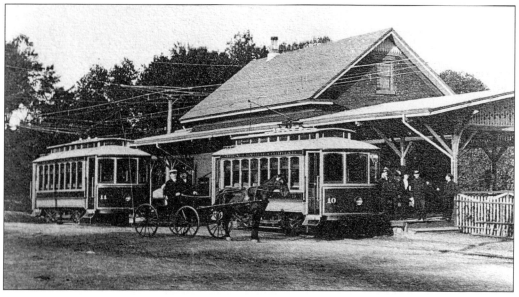

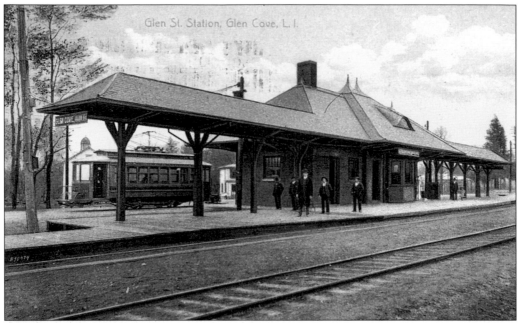

Glen Street Station was built in 1898. A trolley line run by the LIRR and known as the Glen Cove Railroad served the station. It ran from the Glen Cove waterfront to Glen Cove Station, stopping at Glen Street. The waiting room of the building now has a beautifully restored fireplace, for decorative purposes only.

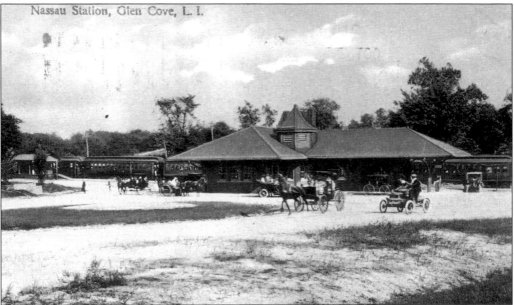

Glen Cove Station was used in the 1954 film *Sabrina*, staring Audrey Hepburn and William Holden. Built in 1895, the building is described by railroad historian Ron Ziel as "an L-shaped brick architectural gem." The octagonal tower on the north side can be seen in this view. Inside the waiting room is the longest continuous bench on the LIRR, running 35 feet. Behind the west waiting room wall, there is a gorgeous fireplace, with 10-foot-high wood columns on each side. (Courtesy of Carol Mills.)

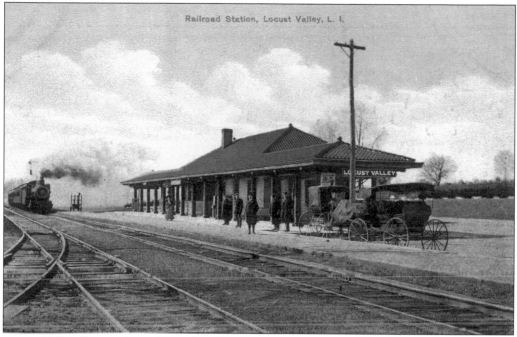

Railroad Station, Locust Valley, L. I.

Locust Valley Station has a Spanish-style tile roof, similar to that of Long Beach Station. The building was opened in 1906. The nearby tower, east of the building, has not been used by the railroad for the past several decades. Currently, the tower is being used by the Nassau County police as a station annex booth. (Courtesy of Carol Mills.)

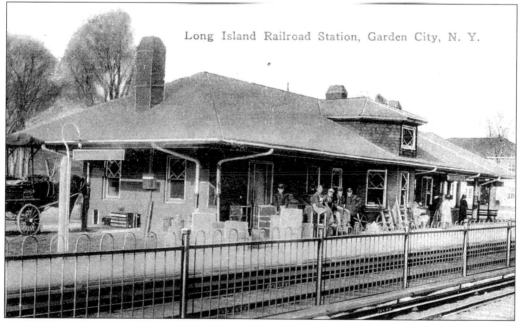

Long Island Railroad Station, Garden City, N. Y.

Garden City Station was built in 1898. The trackside roof dormer is similar to the street-side roof dormer of the Oyster Bay Station building. Many of the leaded glass windows are still intact. This station has a beautiful fireplace, for decorative purposes only, inside the waiting room.

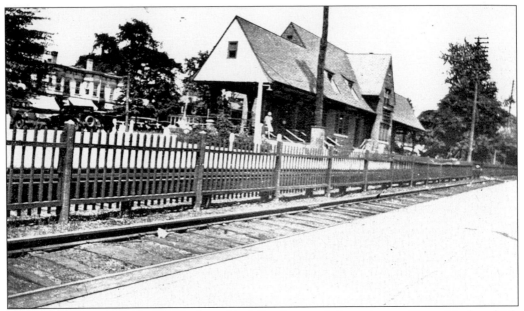

In 1866, the New York and Flushing Rail Road extended service to Great Neck, which remained the eastern terminus until the 1898 expansion into Port Washington. The original building was demolished in 1883 and replaced by a two-story wood structure. The present building, seen in these views, was erected in 1925 and is of English cottage style. This building was at track level until the tracks were depressed in a grade crossing elimination project in 1934. Great Neck is the home station for the U.S. Merchant Marine Academy in Kings Point and for U.S. Olympic figure skater Sarah Hughes.

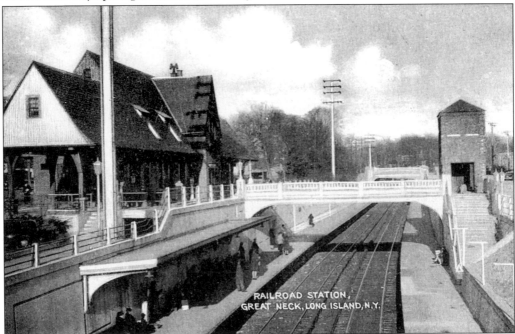

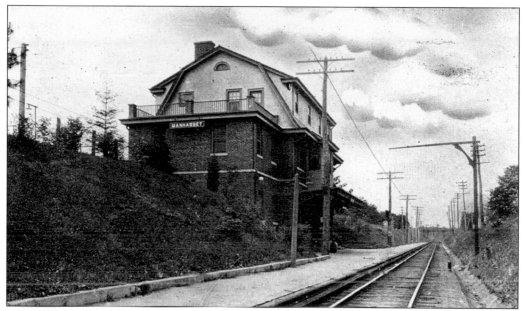

The LIRR reached Manhasset in 1898, with the expansion of service to Port Washington. The Travers Estate donated the land for a station, and a wood-frame depot opened in 1899. The present station building, a unique three-story structure with a freight-express elevator, was erected in 1924. Below, the construction of the Manhasset Viaduct was what made the Port Washington service expansion possible. This steel structure is 679 feet long and 81 feet above water level. Seven steel piers, which required 480 tons of steel to build, support the bridge. To this day, the viaduct is the highest bridge on the LIRR. (Above, courtesy of Robert Myers.)

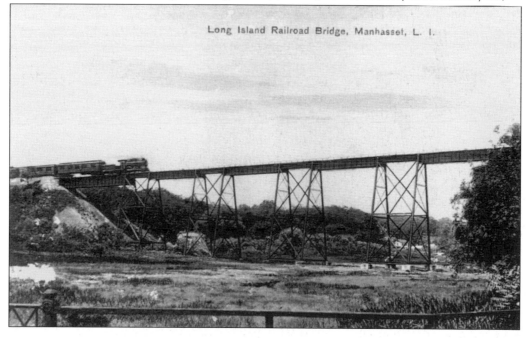

Long Island Railroad Bridge, Manhasset, L. I.

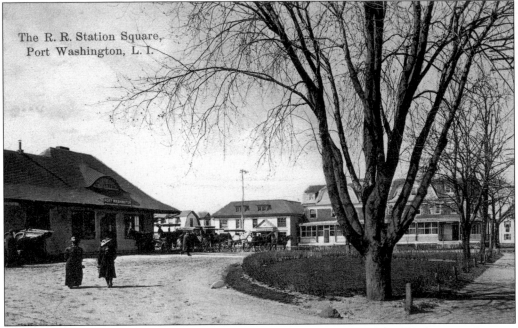

The R. R. Station Square,
Port Washington, L. I.

On June 23, 1898, LIRR president William H. Baldwin Jr. was at Port Washington Station, along with local community leaders and throngs of residents, shown below, to welcome the first passenger train into the hamlet at 11:40 a.m. The train engineer was William Graven, whose descendants are still in the area. Several of Graven's descendants were at the 100th-anniversary ceremony that was held at the station on June 27, 1998. The station had been nicely restored by LIRR engineering forces, including restoration of the trademark eyebrow window on the street side of the roof. The branch was electrified in 1913. (Above, courtesy of Carol Mills.)

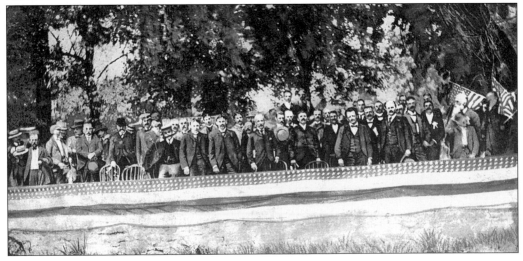

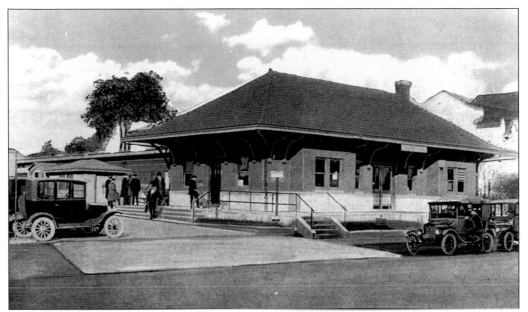

The brick Hempstead Station building was erected in 1913 and was located three blocks from its present location. In 1943, the building was moved to a new location on Columbia Street, where it existed until a few years ago, when it was demolished and a larger structure was built as part of the Hempstead Transportation Hub complex.

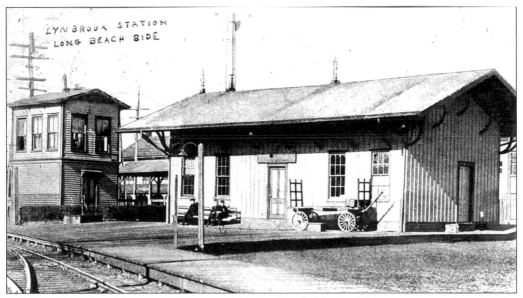

In 1881, a board-and-batten station opened in Lynbrook. The building was stuccoed over in the 1920s. It was demolished in the 1938 grade crossing elimination project. In this view the old signal tower is seen at the left. (Courtesy of Vincent F. Seyfried.)

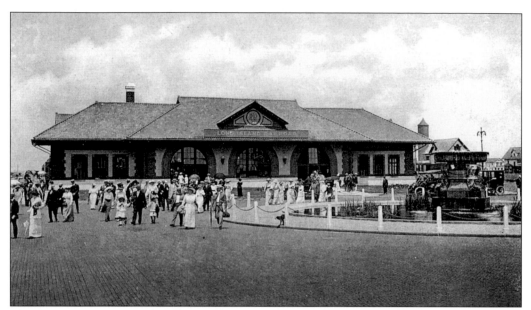

The Long Beach Station building opened in June 1909, a year prior to the run of the first electric train to Penn Station, on September 8, 1910. This building is brick and stucco with stone trim. The roof is Spanish-style tile. The large brick arches over the center windows and a pointed roof dormer make this building unique. Although the original building was closer to the water, this building is only a short walk from the beach. It was handsomely restored by the LIRR a few years ago.

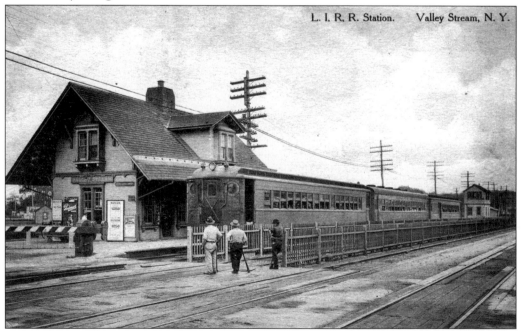

Valley Stream first appeared on the timetables in 1869. The station building, erected in 1870, is the only LIRR station built in a Swiss chalet style. A clapboard structure with a slate roof and a peaked roof dormer, the building stood until the 1933 grade crossing elimination. The signal tower can be seen in the right background. (Courtesy of Carol Mills.)

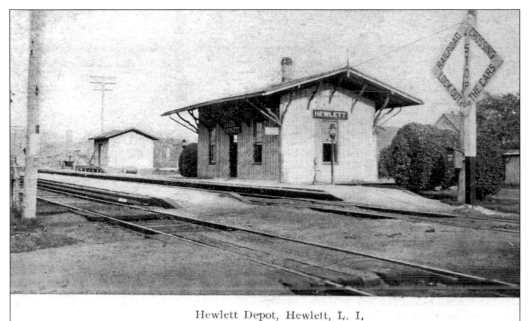

Hewlett Depot, Hewlett, L. I.

The South Side Rail Road constructed Hewlett Station in 1870. It is the oldest station building on the LIRR today and the only existing building erected by an LIRR predecessor. It is a board-and-batten structure with large roof eaves supported by long brackets. In the late 1990s, high-level platforms were installed at this station at a point farther west to allow the old station to retain its original character. (Courtesy of Carol Mills.)

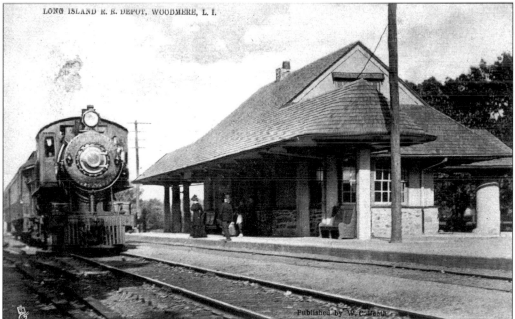

Woodmere first appeared on the timetables in 1869. A wood-frame building was erected in 1870 and replaced by a new structure in 1902. The platform canopy on the trackside of the building has conical ends on each side of the roof. On the street side of the building, there was a porte-cochere, which has since been removed. (Courtesy of Carol Mills.)

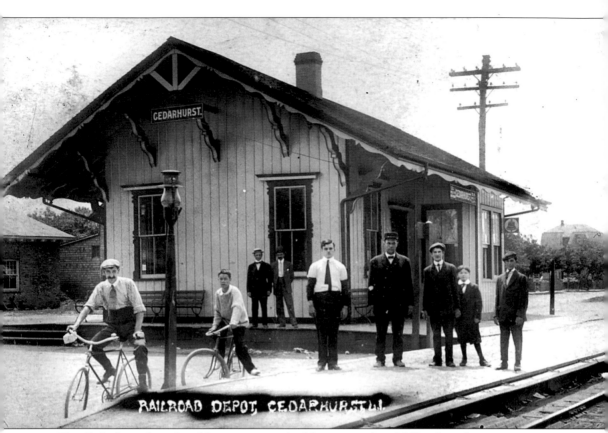

The Cedarhurst board-and-batten station building opened in 1869, when the community was known as Ocean Point. The name was changed to Cedarhurst in 1890. This is a rare view as it depicts people standing in front of the station. The man in the middle, with the white shirt and necktie, is probably the station agent. In 1913, this building was replaced with a masonry building, which is still standing. (Courtesy of Vincent F. Seyfried.)

Four

SUFFOLK COUNTY, NORTH SHORE STATIONS

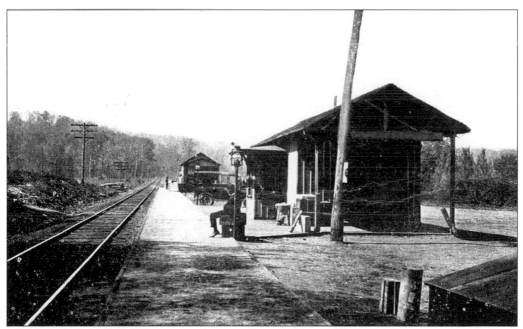

The first station building in Woodbury was erected in 1875. The name was changed from Woodbury to Cold Spring on October 15, 1880. The name was later changed to Cold Spring Harbor due to the fact that the post office disallowed two towns in a single state from having the same name; Cold Spring already existed on the Hudson River. The 1875 building was demolished in 1948 and replaced with the present brick box structure. During the 1980s, this station had a dog named Brandy as a mascot.

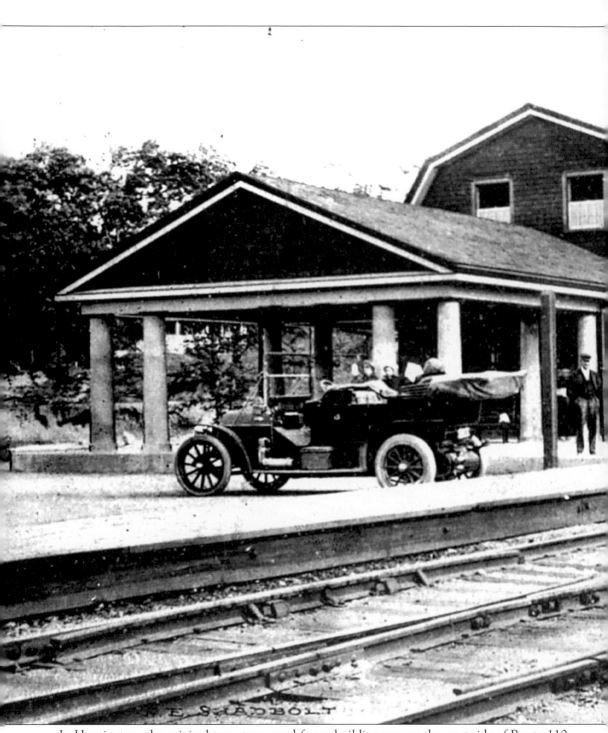

In Huntington, the original two-story wood-frame building was on the west side of Route 110, north of the tracks. In 1909, a new building, which still stands and is pictured above, was built east of Route 110 on the north side of tracks. This station has a gambrel roof, two slopes on each side, and two roof dormers on the trackside and street side of the building. Canopies with

support columns are on each side of the building. In this view the Huntington–Amityville Trolley can be seen in the right background. Photographs of the construction of the station building and the Route 110 overpass bridge are on display in the station waiting room, courtesy of Bill Ahern, whose grandfather Thomas Doran was the foreman of the construction project.

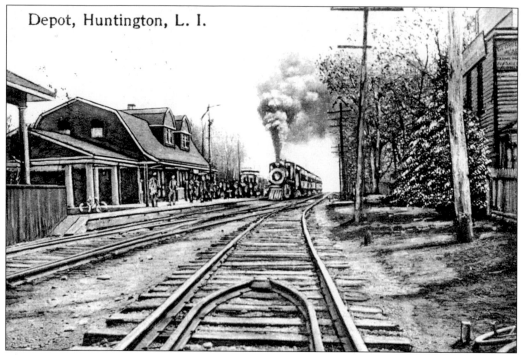

Depot, Huntington, L. I.

This scene at Huntington is quite different from today's view, which includes canopied high-level platforms on each side of the tracks, three pedestrian overpass bridges, and huge parking garages on the north and south sides at the east end of the station. The new platforms and overpasses were constructed in 1998 during a huge capital project program. Fortunately, the station building and the stone-slate roof shelter on the south side were allowed to retain their historical character.

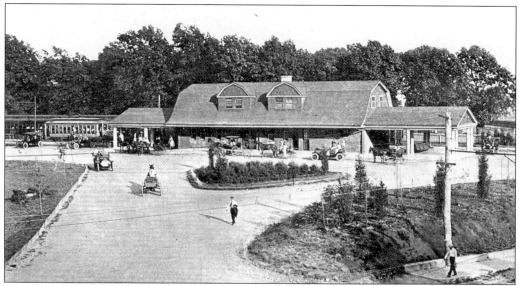

At the right is the Route 110 embankment and a trolley pole on the corner. The trolley line made a wide loop, ending at the east end of the station building. The trolley can be seen in the left background. The parking lot no longer has the center island.

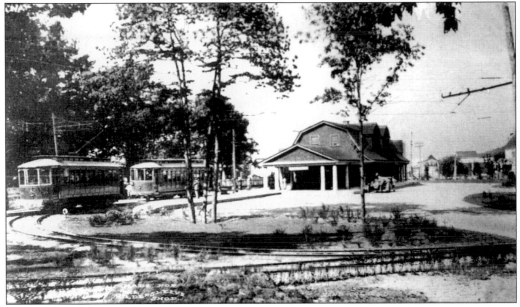

In 1909, there was a massive grade crossing elimination project at Huntington Station to prepare for the Huntington Amityville Trolley line. The trolley ran along what is now Route 110, one of Long Island's heaviest traveled and most congested roads. The trolley cars started at a dead-end track at the southeast corner of the station building, the location where the coffee truck has been for years. The trolleys made a loop over to what is now Route 110, then went south, and at Farmingdale made a trip west to stop at that station. Trolleys then returned east to Route 110 and proceeded south to Amityville.

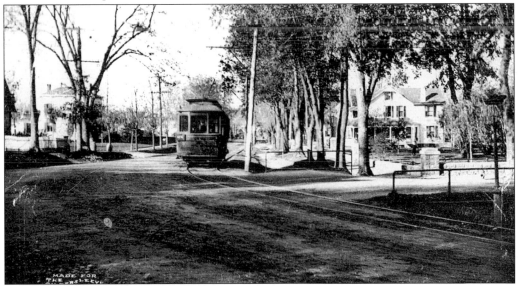

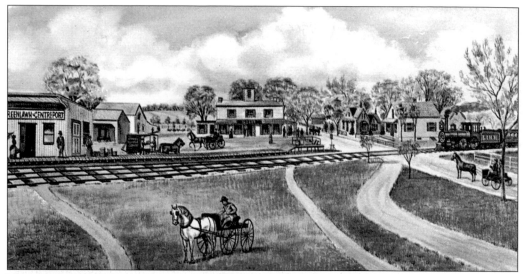

The above postcard was from the Franklin National Bank – Historical Series, and the caption on the reverse side reads, "Greenlawn-Centerport LIRR Station and surrounding area, as it appeared in the mid-1800s. Courtesy of Huntington Historical Society. Water color by Charles Berger." It is interesting that this artwork closely resembles a print done by the famous Long Island artist Edward Lange, who drew many Long Island landscapes during the 19th century. That print is in the archives of the Greenlawn-Centerport Historical Society and is reproduced below. Was the postcard artistic plagiarism? You be the judge. (Below, courtesy of the Greenlawn-Centerport Historical Society.)

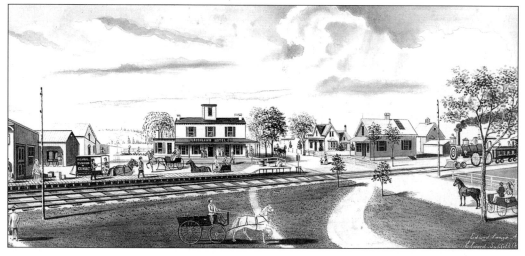

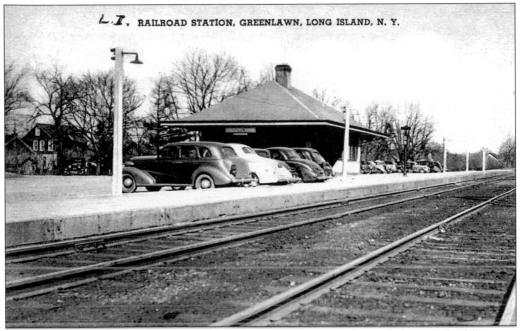

The original Greenlawn Station building burned down in 1909, and the new building was constructed on the east side of Broadway in 1911. That building still exists today, and inside the waiting room is a decorative potbelly stove that was donated and placed by Greenlawn resident and retired LIRR foreman Paul Proctor. The view below illustrates the quaintness of the Greenlawn area.

The Junction R. R. Bridge Greenlawn, L. I.

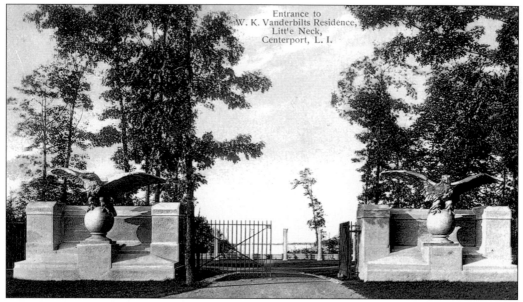

Entrance to
W. K. Vanderbilts Residence,
Little Neck,
Centerport, L. I.

What are these eagles doing in a LIRR station book? Well, they are from a railroad station and they are now on Long Island, so it can be said that they belong. These two cast iron eagles are inside the main gate of the Vanderbilt Museum in Centerport, a short distance north of the Greenlawn Station. The eagles used to be atop the former Grand Central Station building in New York City, shown below. In 1910, when that building was demolished to make room for the present Grand Central Terminal, the eagles were removed and dispersed to various parts of this region. William K. Vanderbilt took two of the eagles to have placed on his estate, which is now a museum.

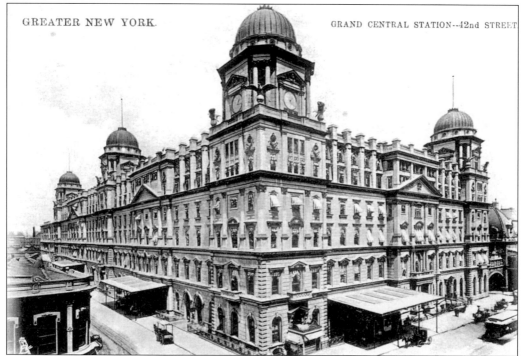

GREATER NEW YORK. GRAND CENTRAL STATION--42nd STREET

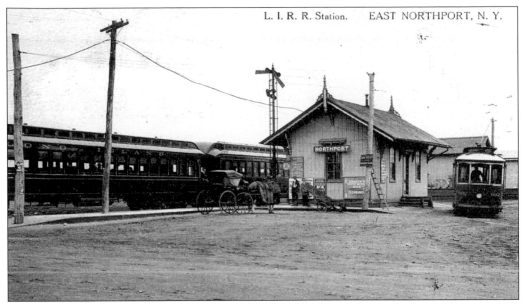

The East Northport Station building was erected in 1873, coinciding with the expansion of the LIRR east to Port Jefferson. The present Northport Station building replaced this old structure, which was moved to East 10th Street, where it was used as a sign company office until it was demolished in 1959. East Northport was served by the trolley cars of the Northport Traction Company. The LIRR formed this company for the purpose of carrying its passengers from the station to downtown Northport. The town was more than a mile from the tracks on a downhill grade. The steam locomotives would never have been able to make it back up the grade, so the railroad provided this trolley service. Below is one of the trolleys in the downtown area.

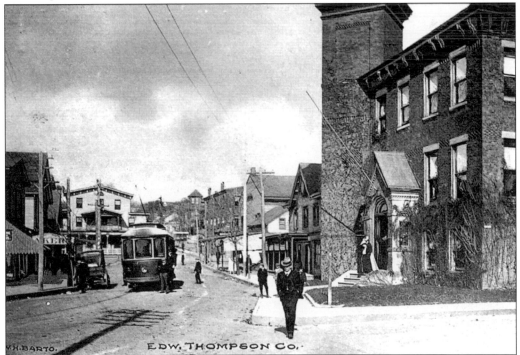

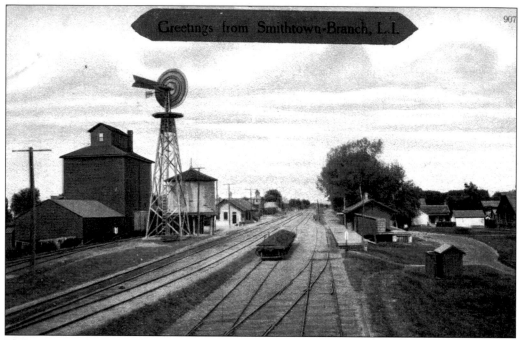

Greetings from Smithtown-Branch, L.I.

This is an interesting view of the Smithtown Station area in the early part of the 20th century. The windmill, at the left, provided power to pump water from the ground into the nearby water tank for the purpose of satisfying the thirst of the railroad's steam locomotives. The station building is also shown. Below is a closeup view of the 1873 station building. In 1937, the old wood building was replaced by the box-style structure that stands today. The 1873 building was moved to Lawrence Street, where it became a private residence. The home is easily recognizable as a former railroad station building. (Above, courtesy of Carol Mills; below, courtesy of Vincent F. Seyfried.)

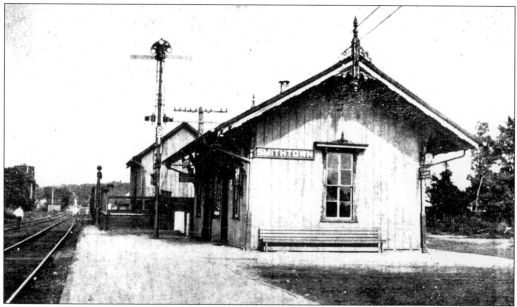

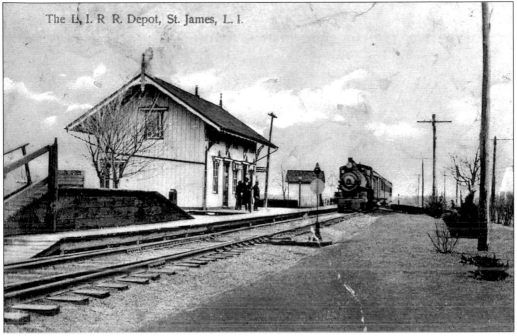

The 1873 St. James Station building is often considered the crown jewel of historic LIRR stations. It is the oldest surviving station building constructed by the LIRR, and it is the only building on the railroad with its original potbelly stove still in the waiting room. Led by Janet Elderkin, who became known as "the Spirit of St. James," the community saved this station from demolition on a number of occasions. The building was restored in 1997.

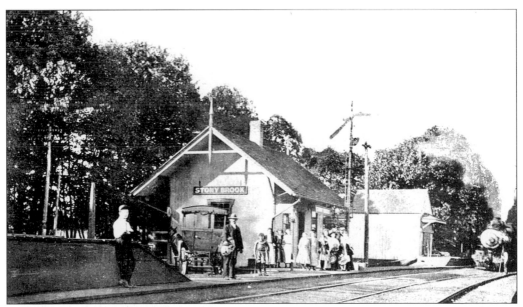

Stony Brook acquired its station building in 1873. This view shows a steam locomotive–drawn train entering the station and a crowd, trackside, ready to board. Also shown are a horse-drawn buggy and a signal semaphore.

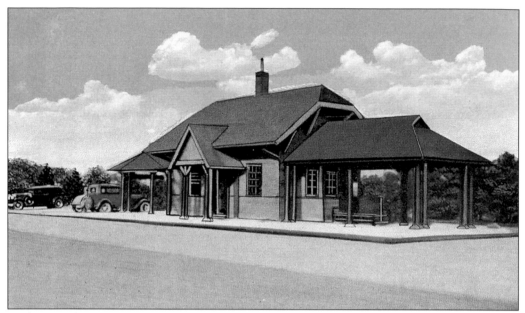

Looking at the prior view and comparing it to this one, it is hard to imagine that this is the same Stony Brook Station building. The structure was extensively rebuilt in 1917. In the words of railroad historian Ron Ziel, "few will dispute the opinion of many that Stony Brook on the Port Jefferson branch is the epitome of the country railroad station."

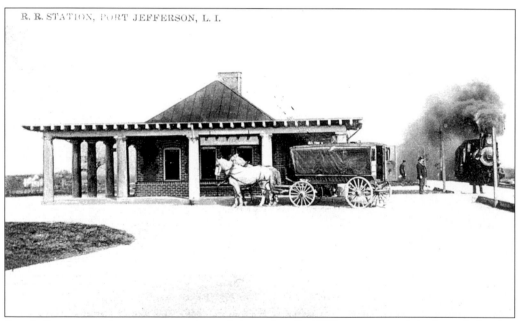

R. R. STATION, PORT JEFFERSON, L. I.

Port Jefferson was the eastern terminus of the railroad's 1873 extension of the branch by that name. The original 1873 station building, on the west side of Route 112, burned down on February 1, 1874, and was replaced by a two-story wood station building. In 1903, a new building, shown here, was erected east of Route 112. The stagecoach operated by John "Billie" Brown carried people from the station, down a long hill, and into the town, which is on the waterfront. (Stagecoach history courtesy of Dr. Robert Sisler.)

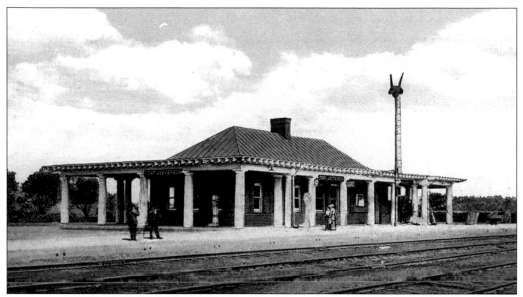

The Port Jefferson Station building opened on July 29, 1903. According to Port Jefferson historian Dr. Robert Sisler, Stanford White of the famous architectural firm of McKim, Mead, and White designed the building and surrounding columns. Similar columns were used on the pergolas on the cliffs of nearby Belle Terra, but those pergolas were washed down the embankment during the 1938 hurricane. The Port Jefferson Station building was recently restored and has a decorative potbelly stove in the waiting room.

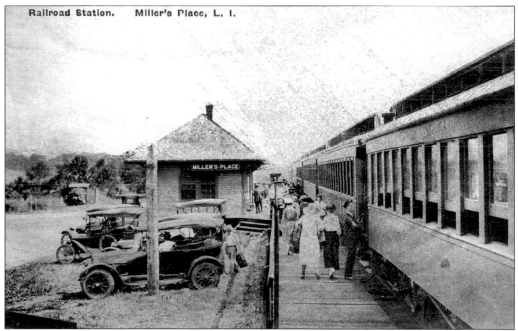

Miller's Place opened as a station stop on June 22, 1895, when railroad service was extended 10 miles east of Port Jefferson to Wading River. The first station building was erected in 1898, but that burned down in 1902. Its replacement, shown above, burned down in 1927, and thereafter there was no station building. Miller's Place closed as a station in 1939.

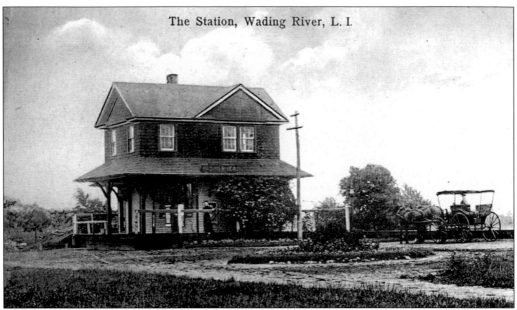

The Station, Wading River, L. I.

Service east of Port Jefferson to Wading River began in 1895 and lasted until March 20, 1939. The original one-story building was enlarged to a two-story structure in 1906. The building was demolished in 1938. After the Wading River branch was abandoned, the railroad right-of-way was purchased by the Long Island Lighting Company and used for a power line right-of-way. (Courtesy of Vincent F. Seyfried.)

A Famous LONG ISLAND Potato

LONG ISLAND RAILROAD

It was in 1905 in Wading River that LIRR special agent Hal Fullerton started the railroad's first experimental farm to prove to the world that Long Island soil could support good crops. Fullerton opened a second farm, in 1907 in Medford, and proved that Long Island was fertile agricultural land. Potatoes were one of Long Island's most successful crops, as is illustrated. This card belongs to the category known as "exaggerated postcards."

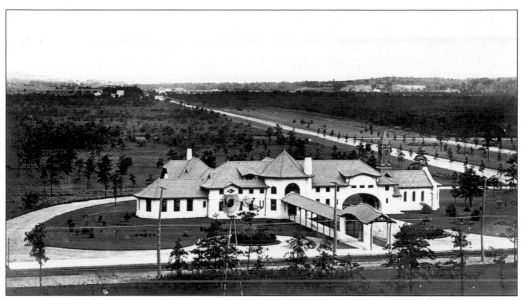

In 1904, a cemetery corporation erected this large white combination station at Pinelawn, north of the tracks and west of Wellwood Avenue. The building consisted of an administration building, church, and crematory. The structure had a covered walkway leading from the tracks to the building. The photograph for this postcard was taken from a nearby water tower. In April 1928, the building burned down and was replaced by a simple frame structure.

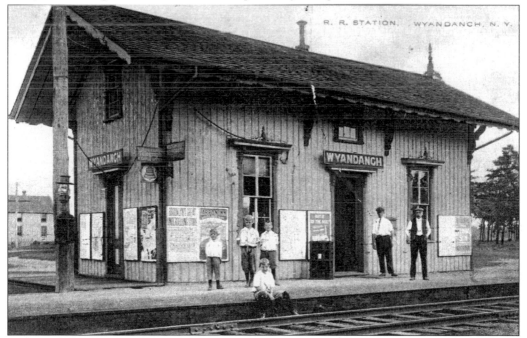

The depot building at Wyndanch was constructed in May 1875 in the same style as the St. James depot. The Wyndanch building was torn down in 1958 as part of a string of station demolitions that occurred during the tenure of LIRR president Thomas Goodfellow. The Wyndanch community evidently did not put up a St. James–type fight to save its station building. (Courtesy of Carol Mills.)

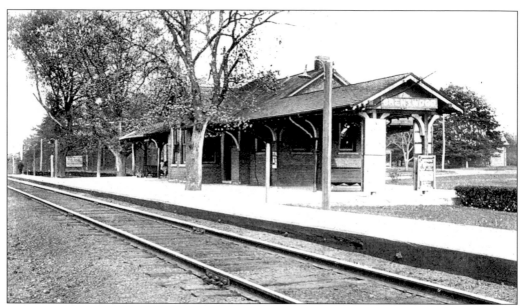

The building that served Brentwood burned to the ground in 1903, and a new station building was opened on November 10, 1903. This building still stands but is no longer in use. A new high-level platform station opened to coincide with the Ronkonkoma branch electrification in 1988. (Courtesy of Vincent F. Seyfried.)

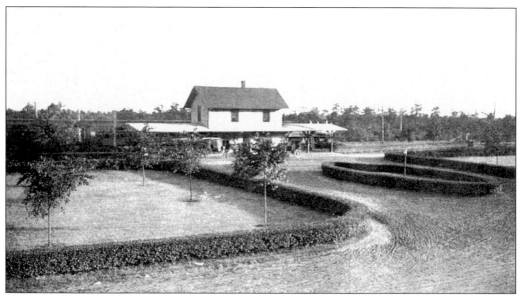

The first train station at Ronkonkoma, then known as Lakeland, was located in the lobby of the Lakeland Hotel, which was originally a farmhouse. In 1883, the railroad built a new station building, which lasted until it burned to the ground in 1934. As shown in this view, the station was in a quiet, rural setting.

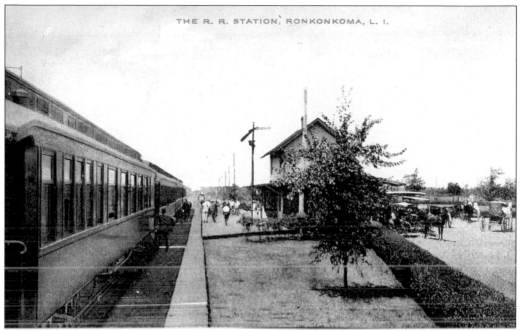

This Ronkonkoma Station postcard is postmarked 1911. The train is stopped at the wood station platform, and on the other side of the building, horse carriages can be seen. A signal semaphore is shown at the center of this view.

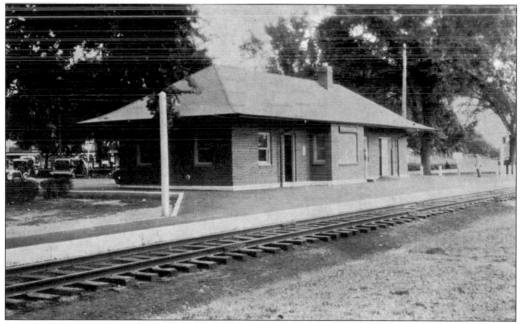

It took a few years to rebuild the Ronkonkoma Station after the 1934 fire, but in September 1937, this brick station building opened. The structure served the public until the Ronkonkoma branch electrification in 1988. A few years later, the building was demolished. Today, a massive station-retail complex, parking garages, and vast parking fields serve Ronkonkoma passengers. (Courtesy of Carol Mills.)

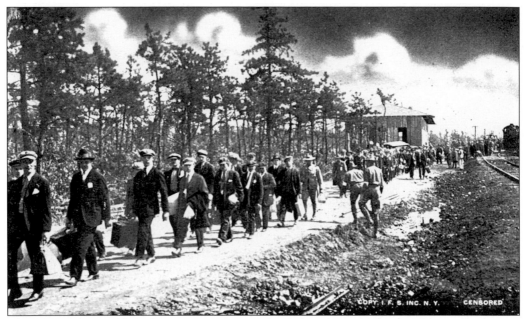

The U.S. Army established Camp Upton in Yaphank during World War I. Thousands of troops passed through this camp throughout the war years. Most were brought in by train, as were many of the animals used at the camp. Irving Berlin immortalized this camp in his song "Yip, Yip Yaphank." The station building stood until 1921, when the camp was decommissioned and the buildings were sold.

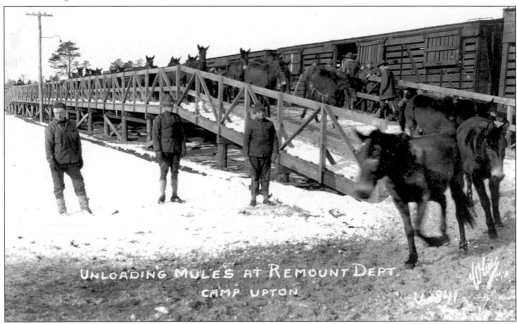

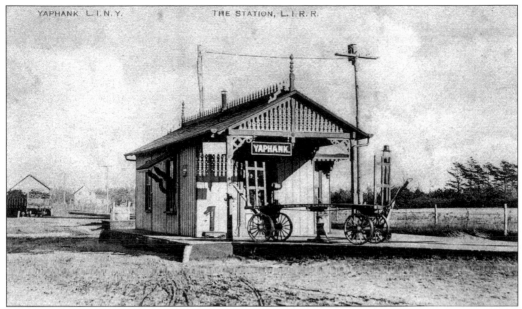

At Yaphank, a frame depot was erected in July 1875. This station was just east of Yaphank Road. It was torn down in June 1941. For years, passengers at this little-used station would board the train from the grass that lined the tracks. In the late 1990s, when all of the railroad's station platforms were raised in anticipation of the arrival of new diesel train equipment, this station received a high-level platform. (Courtesy of Carol Mills.)

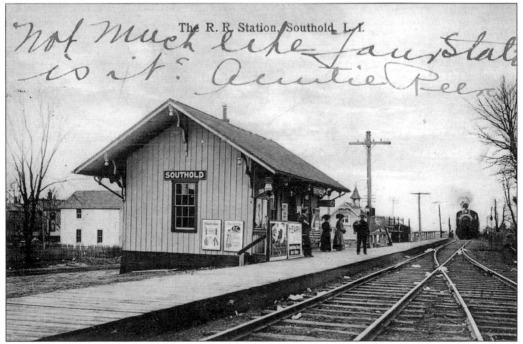

The Southold Station building opened in January 1870 and stood until demolished in June 1962. In the 1990s, this station also received a high-level platform. Southold is in the heart of Long Island's wine-producing region.

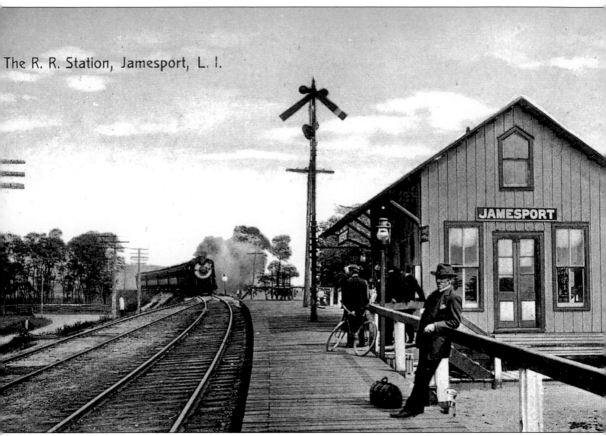

The R. R. Station, Jamesport, L. I.

This postcard of the Jamesport Station also appears on the cover of this book. The building opened in 1878, was remodeled in 1944, and was torn down on July 18, 1963. It was not long thereafter that the station stop was discontinued. To this day, the old asphalt station platform can be seen at this long-abandoned site.

Five

SUFFOLK COUNTY, SOUTH SHORE STATIONS

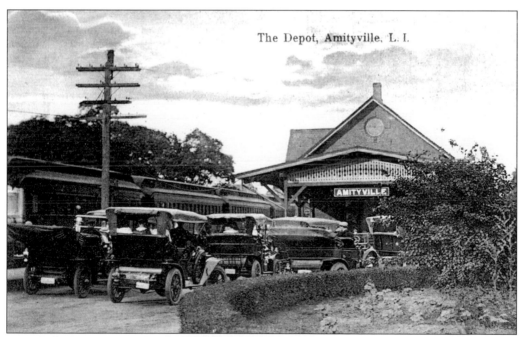

The Depot, Amityville, L. I.

Amityville acquired its first station building in December 1868 on the east side of Broadway, south of the tracks. A new brick building, seen here, was opened on July 25, 1889, at the head of Ketcham Avenue. The original wood-frame building was moved and still stands as a private residence on Railroad Avenue, not far from today's station. No photographs showing the original building at trackside are known to exist.

The 1889 Amityville Station building is seen here in a wide-angle photograph. To the left of the building, on the opposite side of the tracks, the shelter shed can be seen. In the right background, the old freight house is visible. The station building was demolished in 1968 for the grade crossing elimination project.

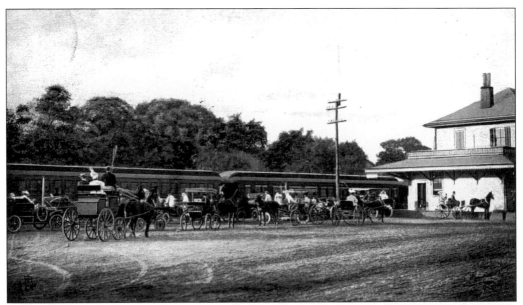

Babylon's first station building was opened in 1868 by the South Side Rail Road, which became part of the LIRR in 1876. On July 2, 1881, the LIRR opened a two-story frame station building that measured 20 feet by 78 feet. At the time it was built, it was the largest station building east of Long Island City. In this view, horse-drawn carriages meet a train at the station.

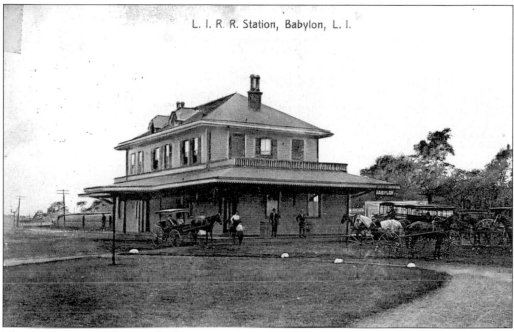

L. I. R. R. Station, Babylon, L. I.

The 1881 Babylon Station building was unique, with it first-story roof running around the building, its scallop trim below, and its wood roof-crest balustrade above. The building was demolished in 1963 for the grade crossing elimination. In the view below, it appears that the engineer is following the time-honored tradition of oiling his steam locomotive. Today, Babylon is the terminal for electric trains on the Montauk branch.

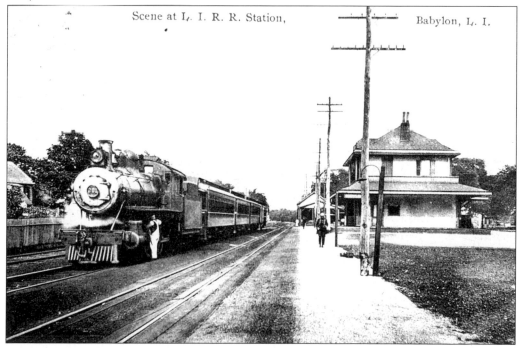

Scene at L. I. R. R. Station, Babylon, L. I.

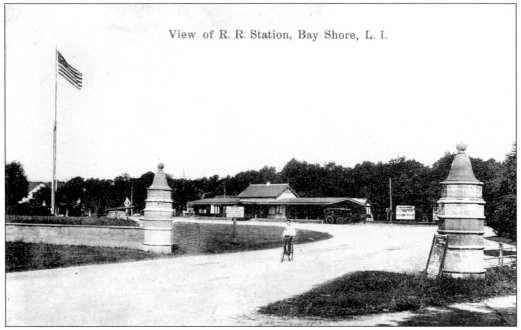

View of R. R. Station, Bay Shore, L. I.

The South Side Rail Road built Bay Shore's first train station, a tiny wood box-type structure, in 1868. In 1882, the LIRR replaced the original building with a wood-frame building with canopies on each side, as seen above. In 1912, a large gambrel-roofed building became the third station at Bay Shore. That station, which still stands, is shown below. These two postcards are interesting companions in that they show the original pillars of the station grounds' entrance gate with the latter-period station buildings in the background.

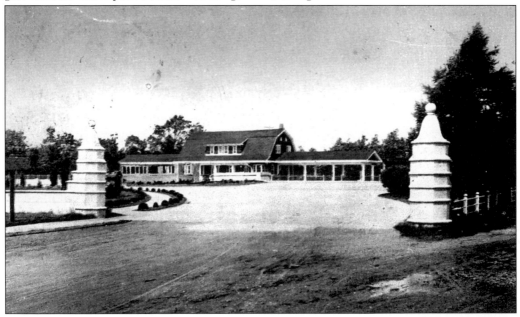

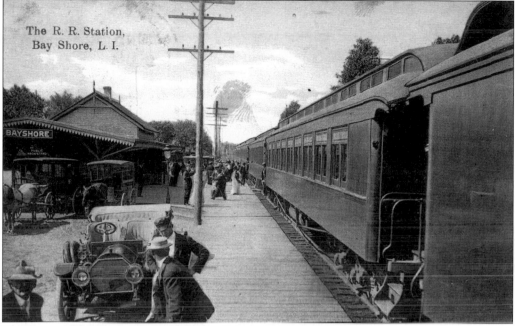

The R. R. Station,
Bay Shore, L. I.

The present Bay Shore Station, pictured above, opened for public use on July 17, 1912. The above view shows the station in its early years. Below is a postcard showing the architectural features of this gorgeous building. Doric columns support the canopies on either side. In 1992, the Metropolitan Transportation Authority (MTA) installed artwork on each of the canopies. Designed by Brit Bunkley, the artwork consists of cast-stone relief panels depicting scenes of local and transportation history. (Above, courtesy of Carol Mills.)

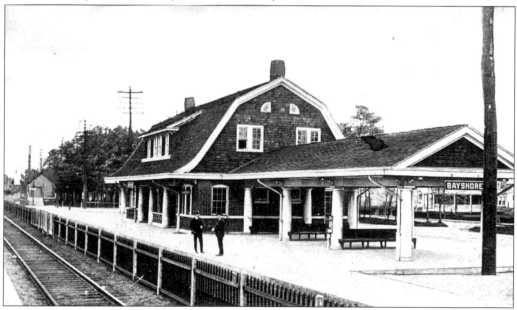

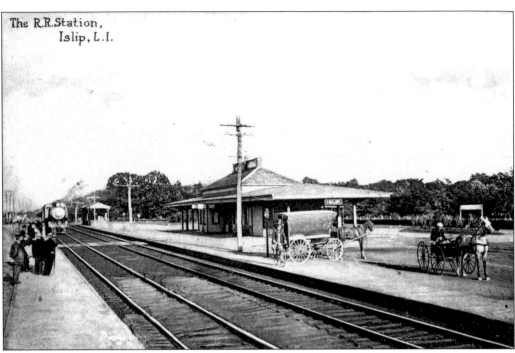

The R.R. Station, Islip, L.I.

Islip acquired its first station building in 1868. The Islip Station building shown above was erected in 1881 and had a canopy running around the entire building. In 1963, this building was demolished and the current building was erected. The 1963 building opened with great ceremony, including the dedication of a locomotive weather vane on the cupola. Several years ago the LIRR Engineering Department renovated the building and built a new cupola with clocks on all four sides and a new locomotive weather vane.

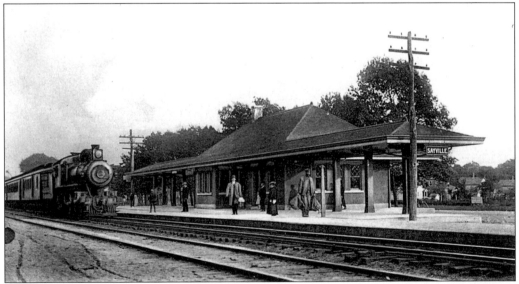

The Sayville Station building was erected in 1905 and still stands. It was built in the Spanish style, with white stucco and a red tile roof. This is a classic "train time" railroad station postcard view.

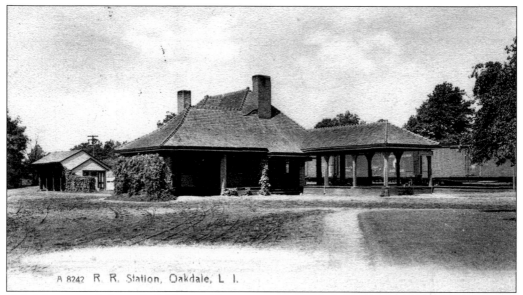

A 8242 R. R. Station, Oakdale, L. I.

Oakdale can truly be called "the wedding station," as it was built for an 1890 wedding and, with a 1994 wedding, became the only LIRR station in which a marriage has been performed. In 1890, William K. Vanderbilt gave the LIRR $90,000 to construct the brick, slate-roofed building for guests attending his daughter's wedding at his estate in nearby Idle Hour. More than a century later, on December 10, 1994, Charlotte Herbert and Edward Wintraecken exchanged vows inside the station in front of the waiting room fireplace. (Courtesy of Carol Mills.)

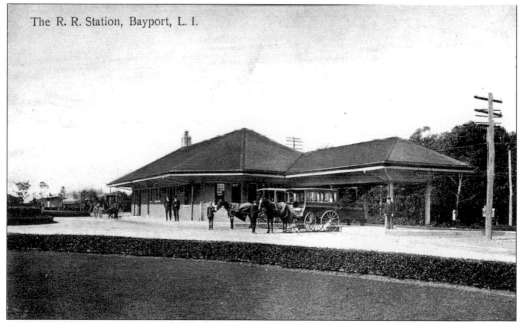

The R. R. Station, Bayport, L. I.

The Bayport Station building opened on August 10, 1903, replacing a small 1869 structure. It was demolished in May 1964, during Thomas Goodfellow's tenure as LIRR president. In the station's final years, a local model railroad club had an exhibit in the waiting room. Bayport was abandoned as a station stop in 1980.

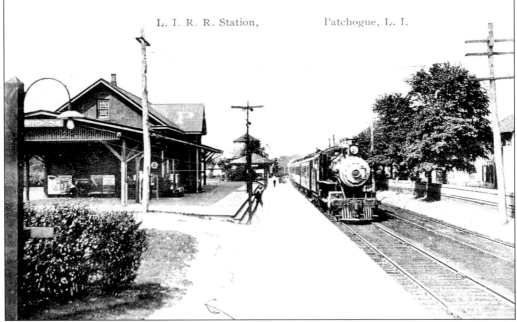

The Patchogue Station building pictured in these views was constructed in 1888 to replace the original 1869 structure. This brick building with canopies on each side was erected at a cost of $5,000. In the view above, the water tank can be seen in the background. The view below gives a clear image of what the old wood station platforms looked like. Demolished in 1963, this building was replaced by the present "jejune edifice" (to quote railroad historian Ron Ziel), which opened on July 30, 1963.

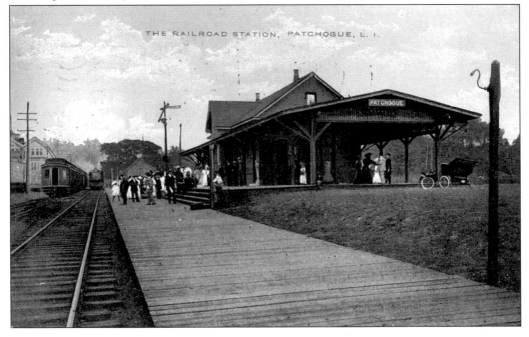

THE RAILROAD STATION, PATCHOGUE, L. I.

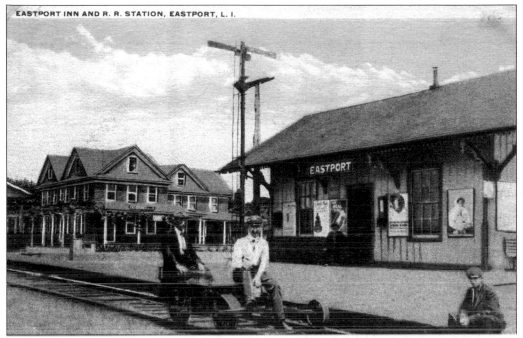

Eastport Station was formerly known as Moriches on the Sag Harbor branch. The building seen in these views was erected in 1870. When the LIRR extended east of Patchogue in 1881, the station became the junction and was renamed Eastport. In 1958, the station was abandoned, or "closed," as the LIRR now likes to say when it discontinues service at a station. (Above, courtesy of Carol Mills.)

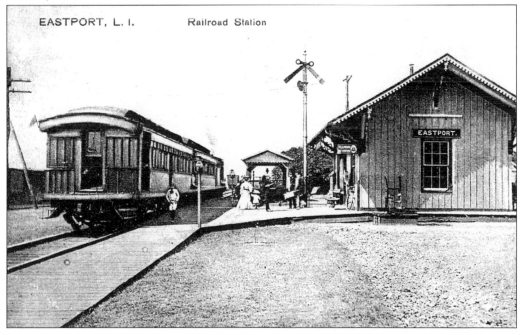

EASTPORT, L. I. Railroad Station

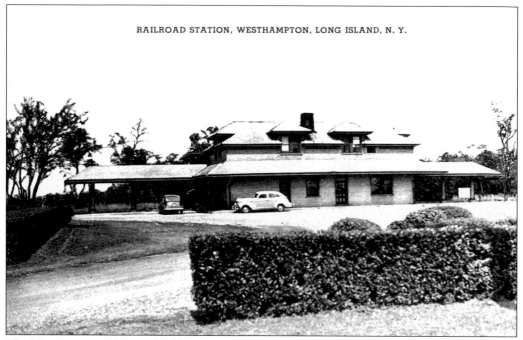

RAILROAD STATION, WESTHAMPTON, LONG ISLAND, N. Y.

The Westhampton Station building, which opened in 1905, is a large brick, two-story structure with six dormers on the second level. This station building burned down in the Westhampton Wild Fire of August 24–25, 1995. Well, not really—but that is what the *New York Times* reported in its August 25, 1995 edition. The story read: "As many as 12 homes, a lumberyard and other businesses and the LIRR station in Westhampton, L.I., were destroyed yesterday by an explosive windblown wildfire." Co-author David Morrison was there on the evening of the fire, and when he left the station, he assumed that he would not see it again. The volunteer firemen did an outstanding job of saving this building.

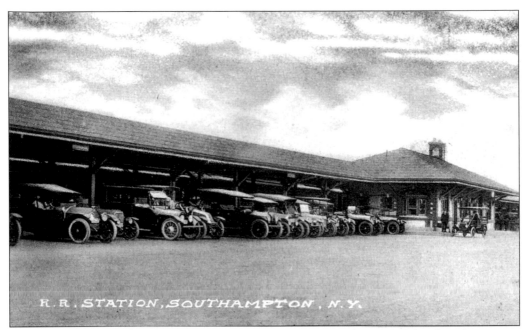

R.R. STATION, SOUTHAMPTON, N.Y.

Southampton Station building, erected in 1902, was unique in design, with brick at the corners and surrounding the windows and doors. Between the bricks were inlaid oyster shells, similar to the design of Oyster Bay Station, which was renovated in the same year. This view looks comparable today, except for the vintage automobiles.

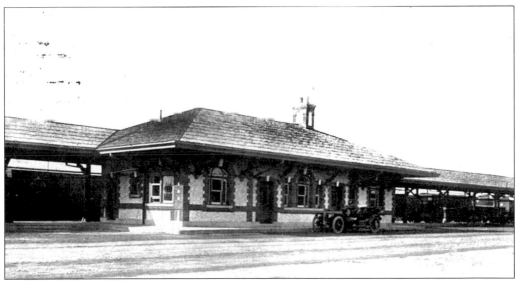

In the waiting room of the Southampton Station was a beautiful fireplace. For decades, ticket agents James Osborne, Charlie Muller, and Larry Shea maintained a museum, with displays of all sorts of railroad memorabilia, in the waiting room and ticket office. Sadly, all that ended when the LIRR abolished the work of agents at this station in November 1996, and these caring railroaders were replaced by a ticket-vending machine.

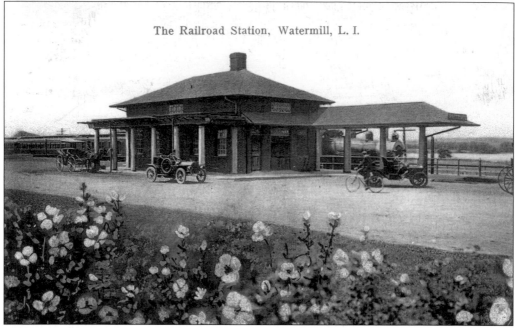

The Railroad Station, Watermill, L. I.

The Watermill Station building was erected in 1903, after a group of local people raised $5,000 for its construction. It was a brick building with canopies on each side. Service was discontinued at this station in the late 1940s. The canopies were removed, and in the 1970s, the building was renovated and became a restaurant. (Courtesy of Carol Mills.)

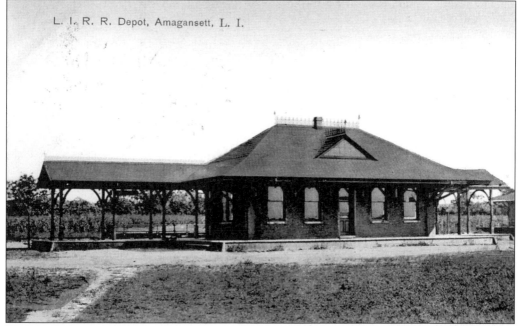

L. I. R. R. Depot, Amagansett, L. I.

This is the original Amagansett Station building, which opened on June 1, 1895. Local residents donated a $1,000 plot of land to the railroad. The depot building cost $5,000 to erect and was identical in design to the East Hampton Station building. Unfortunately, this structure burned down in 1909, reportedly in an act of arson by a disgruntled former LIRR employee.

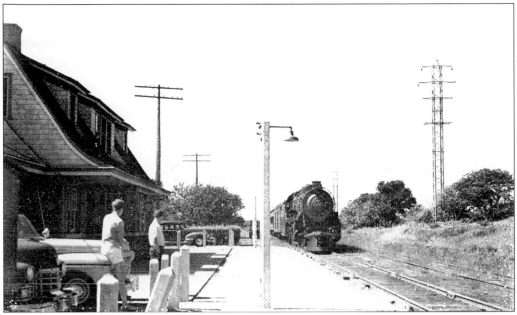

The second Amagansett Station building, which opened in August 1910, was a large two-story, gambrel-roofed structure similar in design to the buildings of the Riverhead, Northport, and Mineola Stations. This building was demolished on August 31, 1964, as ordered by LIRR president Tom Goodfellow. The above view shows a morning Montauk-bound train at the station. Notice the platform light pole in the center. Railroad historian Ron Ziel recovered a number of these and donated them to the Railroad Museum of Long Island. The view below shows the old freight house in the left background.

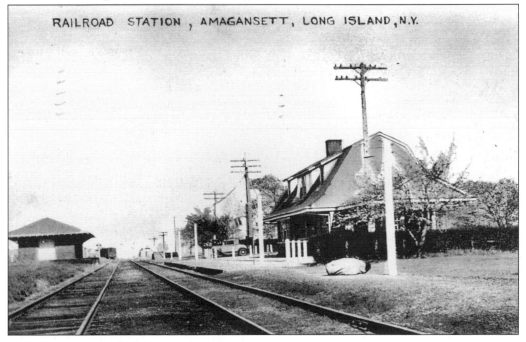

RAILROAD STATION, AMAGANSETT, LONG ISLAND, N.Y.

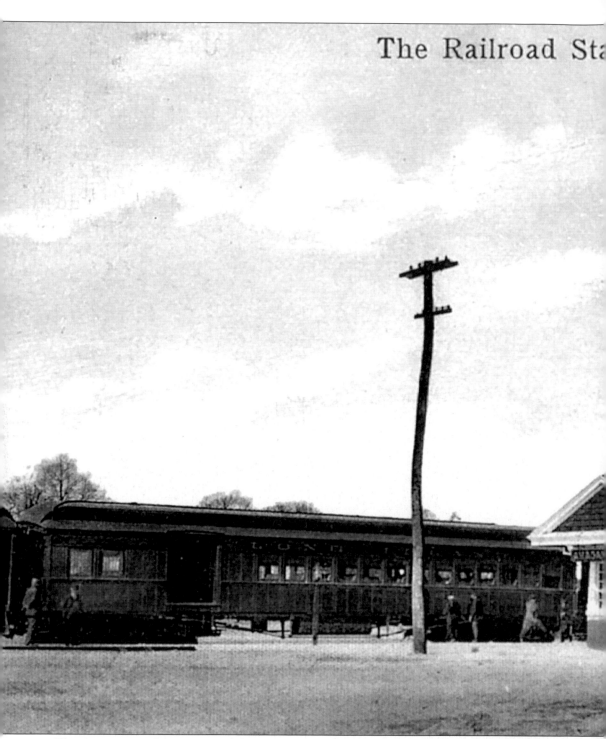

The Amagansett Station gained fame in World War II. On the evening a June 12, 1943, a group of Nazi saboteurs landed on Amagansett Beach from an offshore submarine. The next morning, June 13, they were at the Amagansett Station when the agent opened the facility. They bought tickets and took the train to New York City. They were later captured before they

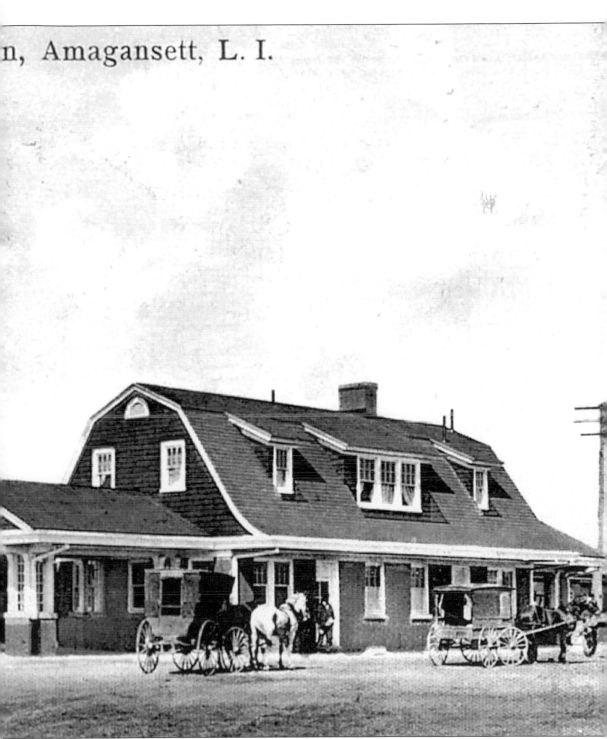

could cause any damage. The job of the station agent was eliminated in 1959, and the building fell into disrepair. In 1964, the building was, in historian Ron Ziel's words, "senselessly destroyed by an unfeeling railroad management."

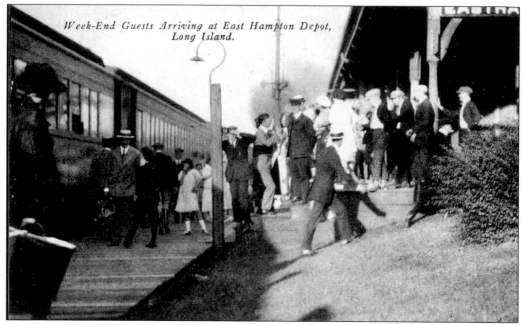

Week-End Guests Arriving at East Hampton Depot, Long Island.

Train service to Easthampton started on June 1, 1895, when through service to Amagansett began. The original station building, which opened in the summer of 1895, is still standing and is one of the few stations that has retained its original appearance both inside and outside. The postcard refers to "week-end guests arriving" and portrays a busy station platform at this exclusive resort community.

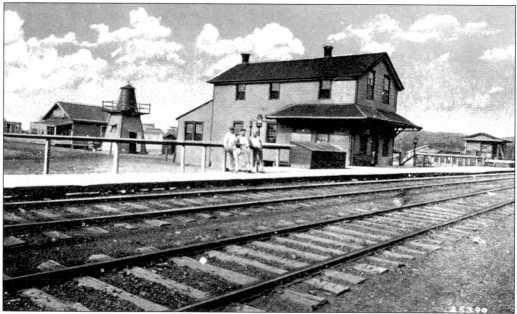

Service to Montauk began on December 17, 1895. The first station building was a single-story wooden structure. A second floor was added c. 1906 to provide living quarters for the agent and his family, and the structure was as seen above. This building was demolished in 1907, and evidently there was no station building until 1927.

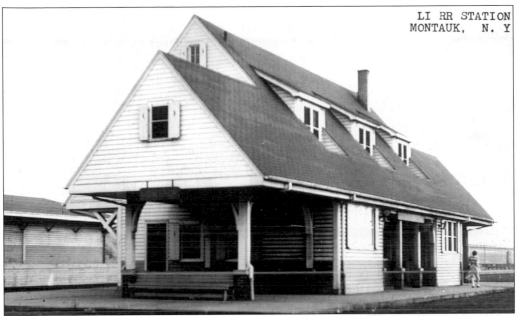

On June 1, 1927, a new two-story station building opened at Montauk. In early 1942, the U.S. Navy took over the Montauk yard and the station building for use as a torpedo storage depot. A new station building, identical in design to the 1927 building, was erected 100 yards south of the original building. Today, the 1927 building can be seen as a private residence in a housing development north of the station building. In the late 1990s, the station building was leased to the Montauk Artist's Association, which uses the space for offices and galleries.

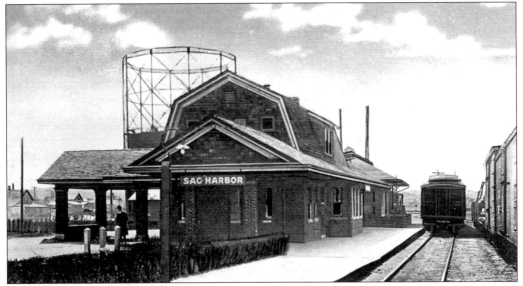

In 1870, the LIRR built a branch on the Greenport main line from Manorville south to Eastport and then east to Sag Harbor. Sag Harbor was the eastern terminal of the LIRR until the Montauk extension in 1895. The station building seen here was opened in 1910 and was in service until the Sag Harbor branch was abandoned on May 3, 1939. The building served as an oil company office until February 1966, when it was demolished and replaced with a bank building.

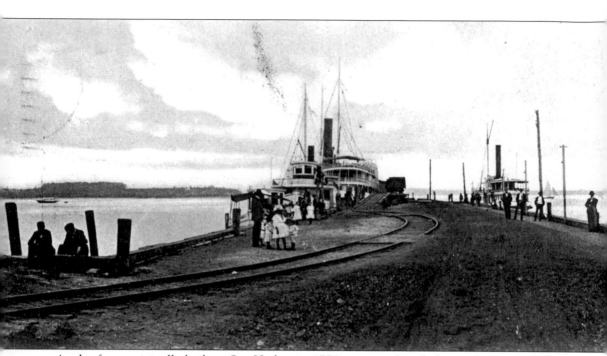

A wharf was originally built at Sag Harbor in 1770 to serve the whaling industry. Excluding Greenport, Sag Harbor was the only village of commercial consequence on the east end of Long Island during the 19th century. In 1888, a new dock was constructed at Sag Harbor and was used by the Montauk Steamboat Company. When the competition became fierce, the LIRR bought out the steamboat company and took over operation of the dock and steamboats in 1898. In 1900, when the Pennsylvania Railroad took over the LIRR, the steamboat operation was overhauled and thrived for another decade. The steamboats ran from Sag Harbor to Pier 13 on the East River and to Greenport, Orient, and New London, Connecticut.

Six

RAILROAD MUSEUMS ON LONG ISLAND

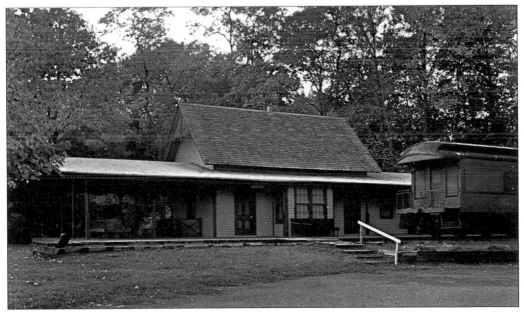

Long Island has four railroad museums. The Wantagh Preservation Society facility is considered one of them, although it is, in actuality, the community museum. This museum resides in two facilities: the station building, at the left, and the railroad observation car *Jamaica*, at the right. The other museums are the Lindenhurst Historical Society facility, the Railroad Museum of Long Island, and the Oyster Bay Railroad Museum. (Courtesy of Milt Price.)

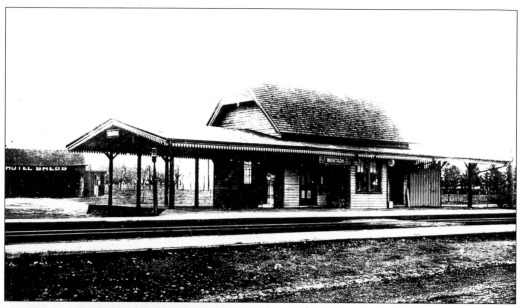

The Wantagh Station was built in 1885 and originally stood on Railroad Avenue, east of Wantagh Avenue. In 1966, when the Wantagh railroad tracks were elevated, the station was moved to its current location to save it from demolition. After this move the station was restored to its 1904 appearance, and in 1982, the Wantagh Preservation Society opened the structure to the public as a museum. The ticket office was restored to reflect the presence of Emma Whitmore, the first woman to serve as ticket agent in the Wantagh Station. (Above and below, courtesy of Joshua Soren.)

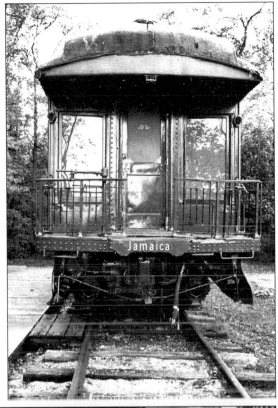

Built in 1912 for the LIRR, the *Jamaica*, at the right, was a magnificent parlor car, complete with solarium, cooking facilities, and an ice-cooled air-conditioning system. It was donated by the LIRR to the Wantagh Preservation Society in 1972. Restoration work on the car is in progress, and the interior has been provided with furniture and exhibits. Below is an interior view of a similar car, the *Oriental*, which was LIRR president Austin Corbin's private car. (Right, courtesy of Alfred Thomson; below, courtesy of Carol Mills.)

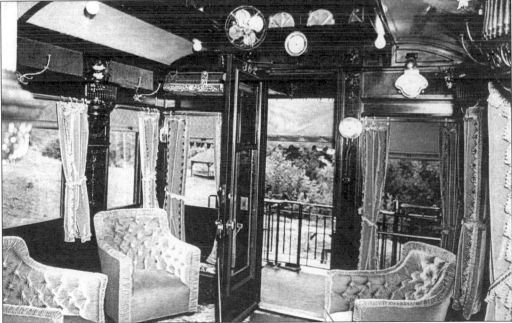

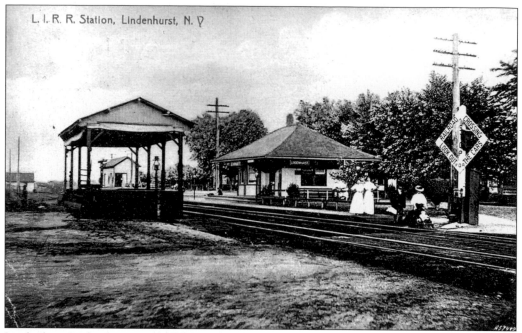

Lindenhurst's third station building, now located on Broadway in Irmisch Park, opened on March 25, 1901. The *South Side Signal*, then Lindenhurst's local paper, reported the depot "is a pretty little structure with low, broad eaves and a cone-shaped pagoda like roof, altogether superior in appearance to the old building. Lindenhurst will have the prettiest depot building between Massapequa and Oakdale, barring none. Some are bigger but there are none as pretty from an architectural standpoint." (Courtesy of Carol Mills.)

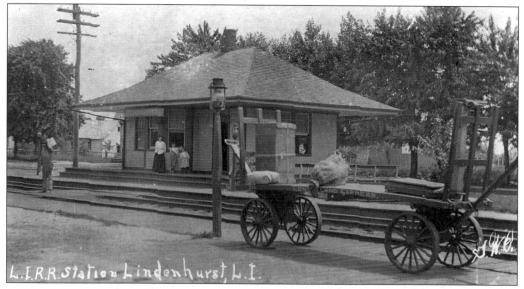

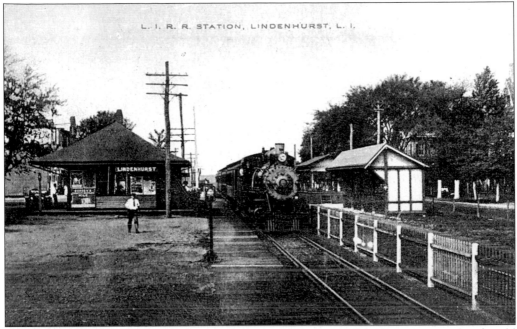

When the tracks were elevated in Lindenhurst in 1968, the LIRR had no more use for the old station building and nearby freight house. On October 25, 1968, the LIRR turned over the keys of the old depot and freight house. The buildings were moved to Irmisch Park and were restored. Exhibits were placed in both buildings, and the facility is now a fascinating railroad museum. A few years ago, the Friends of Locomotive No. 35 donated a caboose to the museum, and it is on display on a short piece of track near the buildings. (Below, courtesy of Carol Mills.)

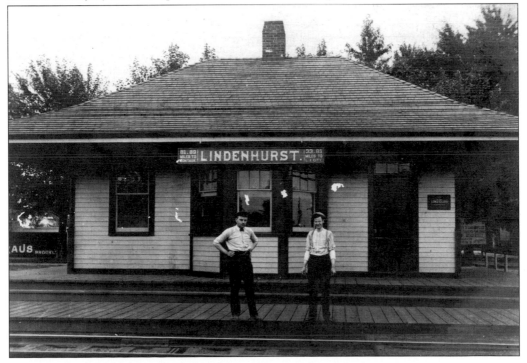

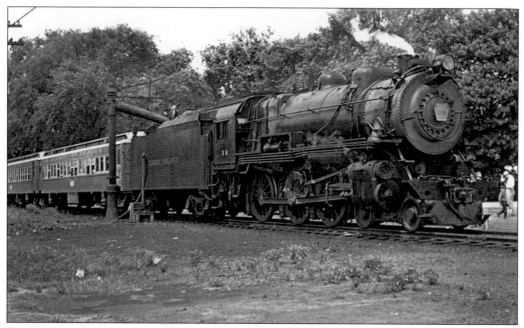

Steam Locomotive No. 39 is the centerpiece of the Railroad Museum of Long Island, based in Riverhead and Greenport. Built in 1928 by the Pennsylvania Railroad, it was one of 31 G-5s locomotives to be used on the LIRR. Retired by the LIRR in October 1955, the locomotive was placed on display at the Carriage House Museum in Stony Brook until it was moved to Riverhead over 20 years ago. The view above shows the engine under steam at Hicksville in June 1955; the view below shows No. 39 on display at the Stony Brook site. (Above, courtesy of Joseph Stark; below, photograph by Edward L. Conklin III.)

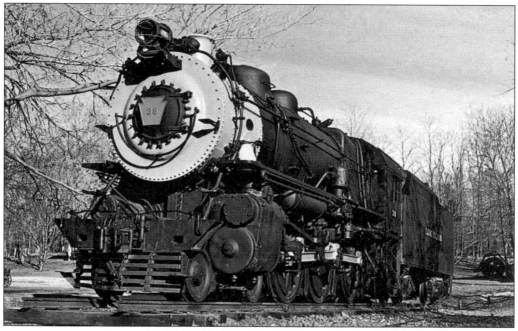

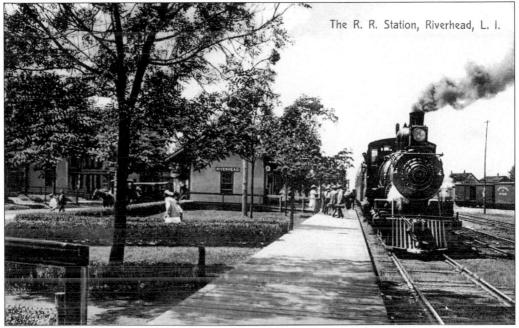

The Railroad Museum of Long Island has its main facility in Riverhead, where most of its equipment, including Steam Locomotive No. 39, is stored. Equipment is on display on tracks north of the station building and in the former lumberyard across the street. Above is the first Riverhead Station building, erected in 1870; below is a view of the platform, with the current station building in the background. (Below, courtesy of Carol Mills.)

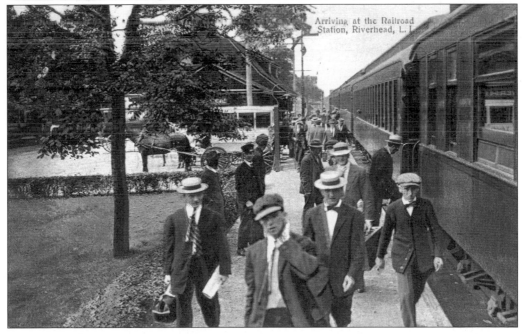

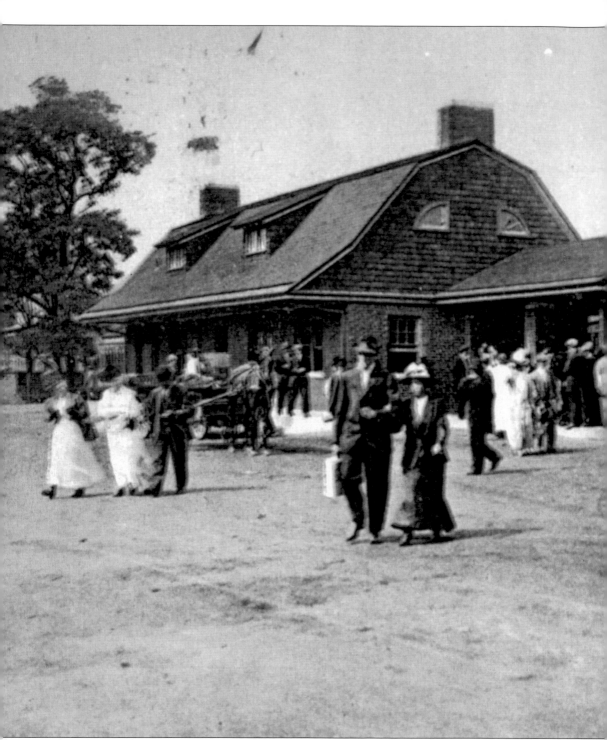

The Riverhead Station building, which opened on June 2, 1910, was another of the two-story, gambrel-roofed stations constructed by the LIRR. The second floor was never finished and was used only as attic storage space by the railroad. In the early 1970s, the agent's job was terminated, and in the late 1990s, a high-level platform was installed east of the station

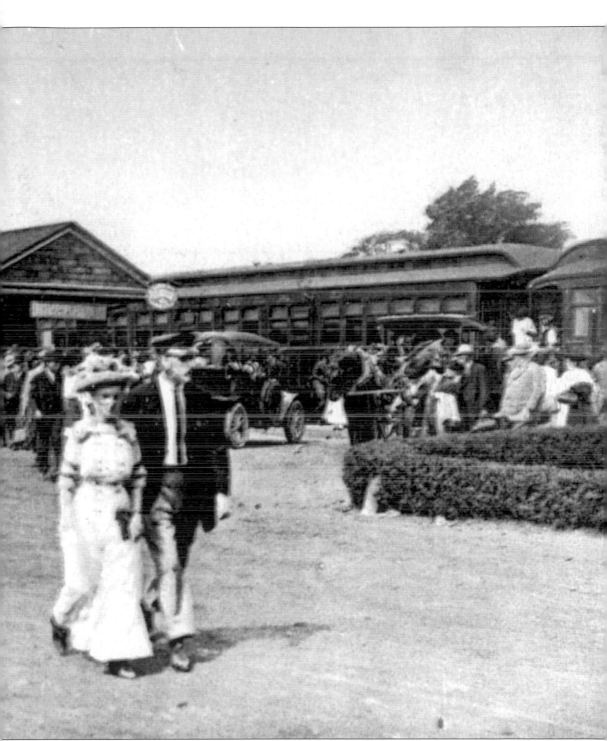

building. The LIRR no longer had use for the building and turned it over to the town of Riverhead for restoration and community use. Although the Riverhead Station building is not part of the museum complex, there are plans to use part of the building when anticipated rail fan excursions begin between Riverhead and Greenport.

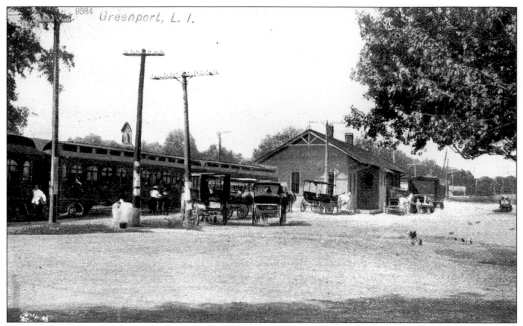

The Railroad Museum of Long Island's other location is at Greenport. This is the location that was the original goal when the LIRR was chartered in 1834. Tracks did not reach Greenport until July 29, 1844, but on that date, the LIRR was considered "complete." In the view above, the wood-frame station building of 1870 is seen. Below is a view of the current station building, which was erected in 1892. The station building is now the home of a nautical museum, while the Railroad Museum of Long Island is housed in the 1892 freight house.

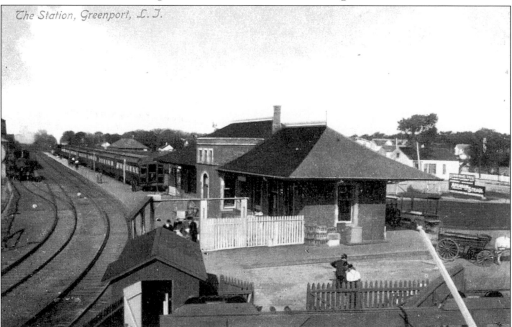

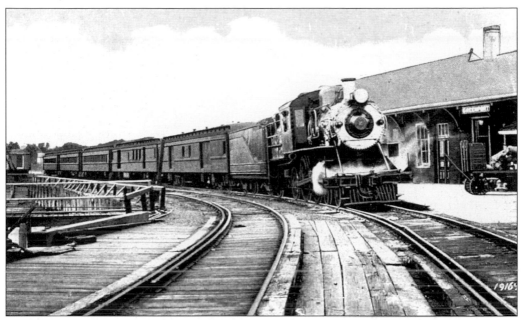

In the 1890s, the tracks used to extend past Greenport Station onto the dock. The above view shows an old steam locomotive-powered train at the station, with the mail and express cars at the head end. The view below shows the old roundhouse and turntable area. The station building is to the left of the roundhouse. The roundhouse was demolished, but the turntable still exists.

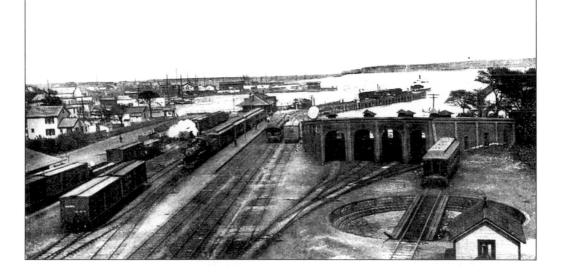

Bird's-eye view of Greenport, L. I.

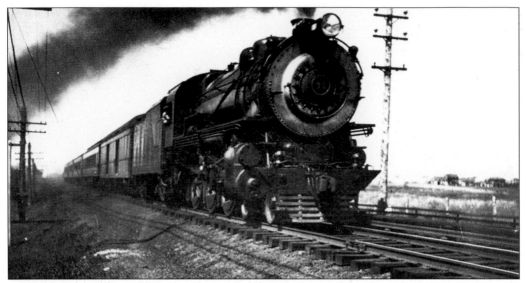

In addition to No. 39, the other G-5s steam locomotive preserved on Long Island is No. 35. Retired in 1955, No. 35 was on display in Salisbury, later known as Eisenhower Park, in Westbury, where members of the Sunrise Trail Chapter of the National Railway Historical Society cared for it. In 1978, it was moved to Mitchel Field, where it was to be prepared for transportation to New Jersey for restoration by the Black River & Western Railroad. That plan fell through, and No. 35 sat in Mitchel Field, still cared for by Sunrise Trail Chapter. The lead person in the early preservation of No. 35 was J. Robert Michele, who devoted many hours of expert attention to the locomotive. In 1990, a small group of individuals took over the care of the locomotive, and the group eventually incorporated as the Friends of Locomotive No. 35. On August 2, 2001, the locomotive was moved to the Oyster Bay railroad yard with the intention that it would become the centerpiece of a new Oyster Bay Railroad Museum. (Above, courtesy of Vincent F. Seyfried; below, photograph by Edward L. Conklin III.)

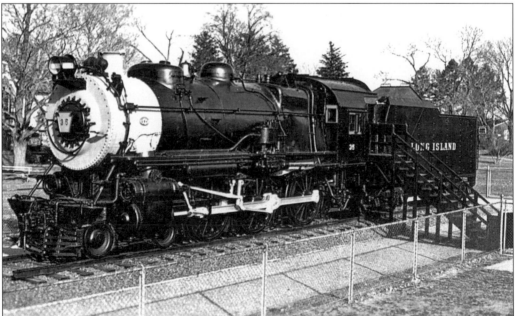

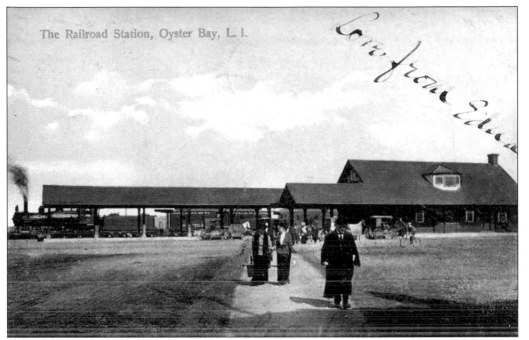

The Railroad Station, Oyster Bay, L. I.

As of early 2003, the LIRR had plans to turn over the Oyster Bay Station building to the town of Oyster Bay for use as the new Oyster Bay Railroad Museum. The railroad reached Oyster Bay on June 25, 1889, and a rather large station building with canopies on each side was opened to the public. In 1902, the building was extensively renovated due to the fact that Pres. Theodore Roosevelt would be returning to Oyster Bay to set up his summer White House at nearby Sagamore Hill. These two early-20th-century views illustrate the dimension of the west end canopies, which were removed in 1941. Otherwise the structure exterior is basically the same, with the exception of the relocation of some doors and windows. (Above, courtesy of Vincent F. Seyfried.)

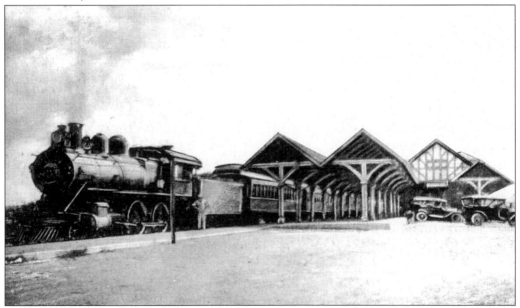

Oyster Bay Station is unique, with its street-side roof dormer above the bay window. Most station buildings have a bay window trackside, but Oyster Bay had bay windows on both sides. The roof dormer resembled the one on the Garden City Station building. The building was brick on the ground level and stucco on the second level, and the stucco had inlaid oyster shells, similar to the exterior of Southampton Station. The large chimney seen on the far end

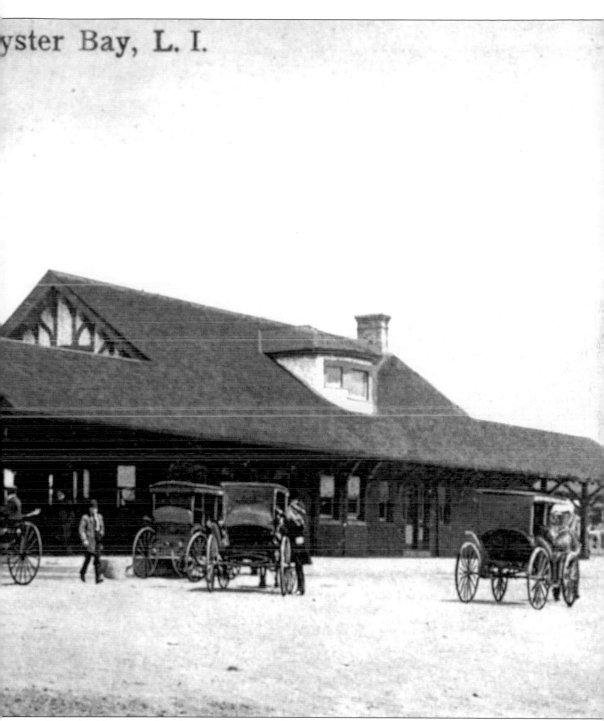

of the building was for the waiting room fireplace. During 1964, the LIRR renovated the interior, removing the fireplace front and walling over the remainder of the fireplace. The expansive waiting room was closed in by the addition of a second floor. The inside looks vastly different from the way it appeared when Theodore Roosevelt was here.

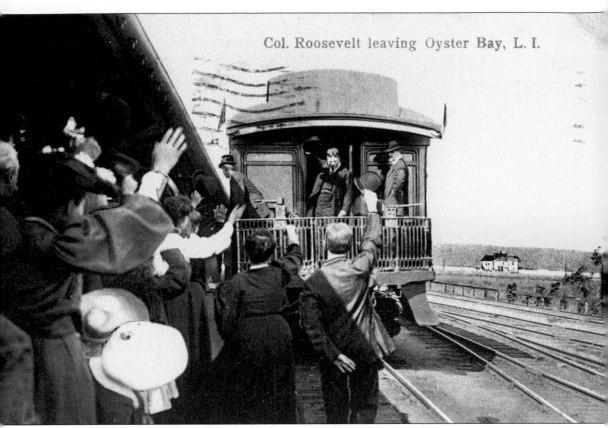

Col. Roosevelt leaving Oyster Bay, L. I.

This postcard shows Col. Theodore Roosevelt leaving Oyster Bay. He was probably riding on the rear of the observation car that belonged to the LIRR president. There were always crowds at the station to meet Roosevelt when his train arrived or departed Oyster Bay. Ironically, it was at about this same location that a historic railroad event occurred on September 30, 1998. It was on that day that the last train departed from a low-level platform on the LIRR. Upon the departure of Train No. 513, with engineer John Zarzicki, conductor Robert Blair, and assistant conductor Jim Scimone, the platform was closed and the new high-level platform, west of the old station, was opened. Oyster Bay Station was the last to convert to high-level platforms. This happened in the same place where Roosevelt used to wave to the crowds.

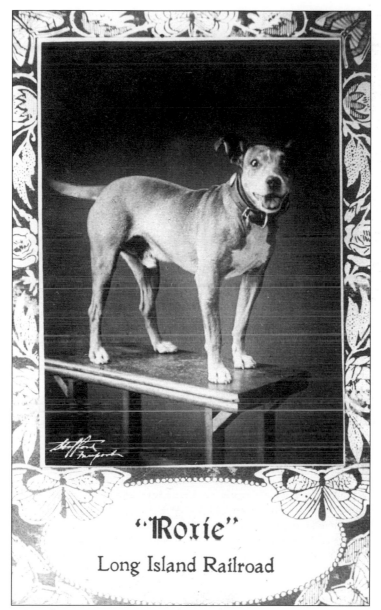

"Roxie"

Long Island Railroad

Roxie was the LIRR's historic mascot. According to the story, in August 1901, Roxie wandered onto a train at Long Island City and ended up getting off at the Garden City Station. There, station agent Heaney took him in and named him Roxie. The dog could not stay put and frequently rode the trains. He become known all over the railroad, and the LIRR president had a collar made for him with the inscription "Roxie, the Railroad Dog." Entered his private car en route to Oyster Bay one day, Pres. Theodore Roosevelt encountered the dog. The porter saw Roosevelt coming into the car and quickly tried to rush the dog out. The conductor explained to Roosevelt that the dog was a pet of all the railroad crews, and the president allowed the dog to stay in his car. Roxie rode the trains until he died in 1914, at which time he was buried at Merrick Station. A canine watering bowl was placed over his grave as a marker. During the grade crossing elimination of 1969, Roxie's monument was preserved and can be seen today at the station. Stafford's Pharmacy of Freeport made this postcard. (Courtesy of Carol Mills.)

Theodore Roosevelt campaigned for the offices of New York governor, vice president, and president by traveling on a train and speaking at the brass railing at the rear of the observation car. He would woo the crowds with his enthusiastic speeches and his vigorous hand gestures. Thousands poured out to meet Roosevelt, as illustrated in the view below at Waverly.

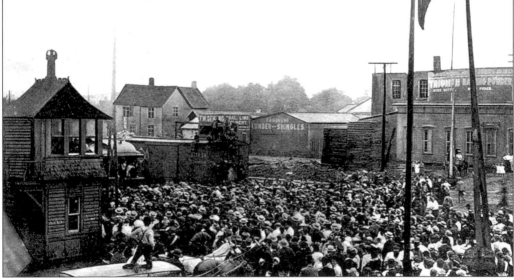

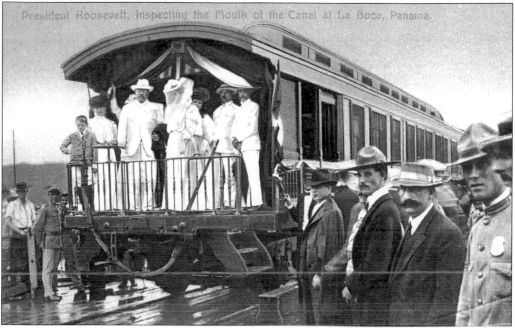

When Theodore Roosevelt visited Panama as president in 1906, he traveled the Isthmus by train, greeting people and inspecting troops from the rear of an observation car. He was responsible for getting the U.S. construction of the Panama Canal started, and he was right there to see the action.

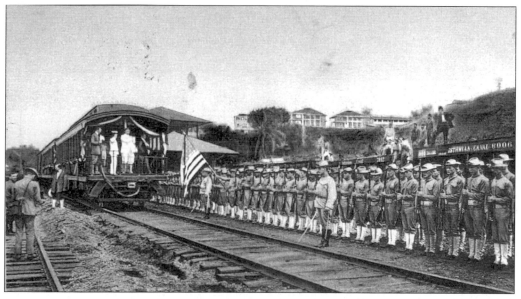

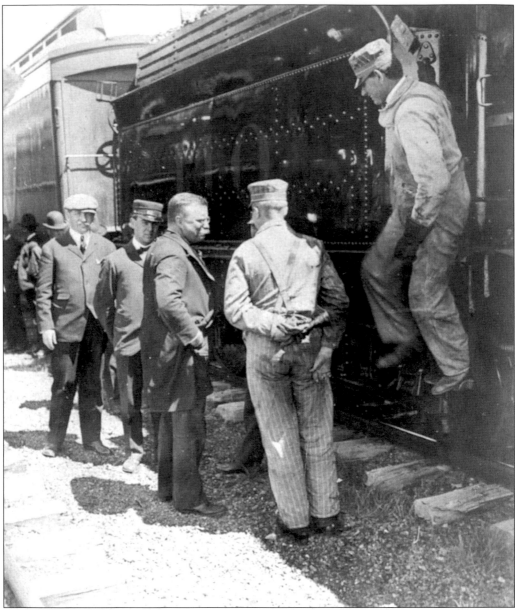

Theodore Roosevelt was very much a railroader's friend. Whenever he traveled by train, which was quite often, he would always go to the head end of the train to shake hands and talk with the crew. He would congratulate the engineer and conductor for a nice run (with the president on board, it was always a nice run), and he would often hand them a silver dollar as a token of appreciation. Here, he is seen with the crew of a Santa Fe train en route to Redlands, California, in 1903. In later years Pres. Harry Truman engaged in this Roosevelt tradition.

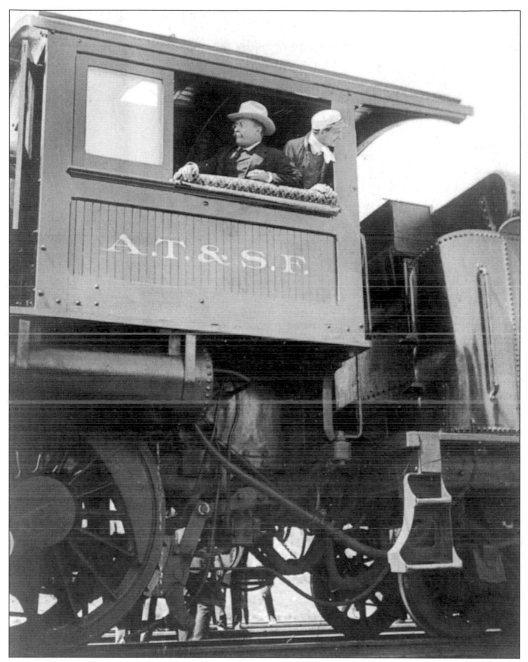

It is said that Theodore Roosevelt knew how to operate a locomotive, and he probably did operate one—with the engineer close behind. Here, he is in the Santa Fe cab, looking as though he belonged.

The R. R. Bridge on West Shore, Oyster Bay, L. I.

There isn't a train I wouldn't take,
no matter where it's going.

—Edna St. Vincent Millay

(Courtesy of Vincent F. Seyfried.)